Character Studies in Oil

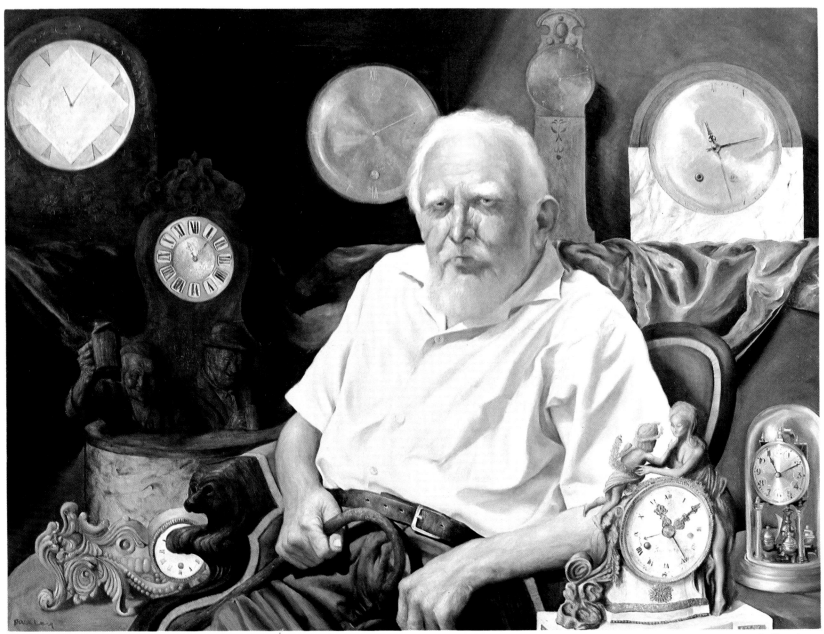

The Clock Collector, oil on Masonite, 30″ x 40 ″. Private Collection.

Character Studies in Oil

BY JOSEPH DAWLEY AS TOLD TO GLORIA DAWLEY

WATSON-GUPTILL PUBLICATIONS, NEW YORK
PITMAN PUBLISHING, LONDON

To our parents, the H. D. Gobbles and the J. W. Dawleys.

Published in the U.S.A. and Canada by Watson-Guptill Publications,
a division of Billboard Publications, Inc.,
1515 Broadway, New York, N.Y. 10036

Published in Great Britain by Pitman Publishing, Ltd.,
39 Parker Street, Kingsway, London WC2B 5PB
ISBN 0-273-31804-7

Library of Congress Catalog Card Number: 79-181488
ISBN 0-8230-0608-5

Manufactured in Japan

First Printing, 1972
Second Printing, 1974
Third Printing, 1977

ACKNOWLEDGMENT

My sincere thanks to Robert Kolbe for his assistance.

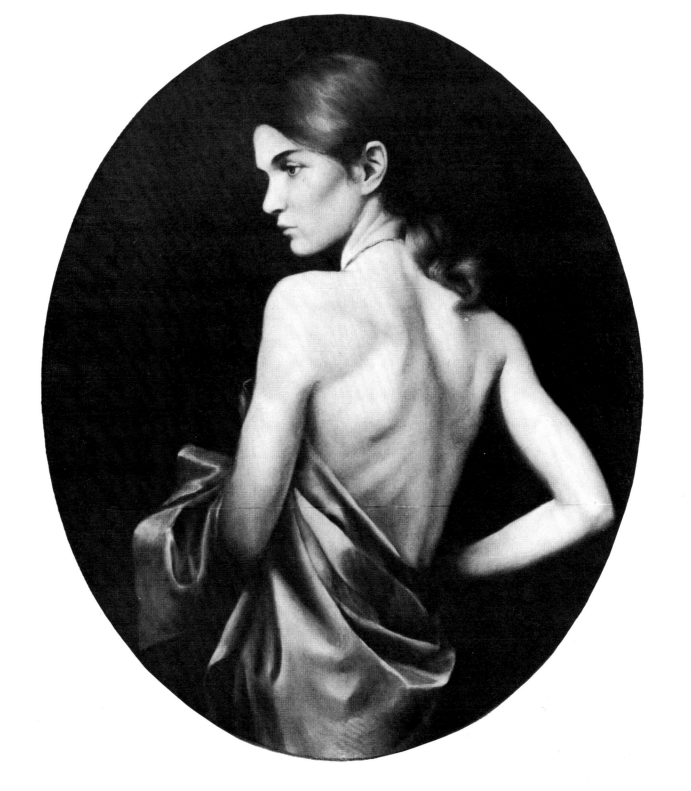

CONTENTS

Girl in the Golden Robe, oil on Masonite, 28" x 22". Collection Mr. and Mrs. Larry Goldsmith. I find that semi-nude studies and folding fabrics complement each other. The graceful curve of the woman's back, the turn of her head, and the flow of her hair are emphasized by and in turn complement the folds of drapery that swirl around her.

The Checker Players, oil on board, 26'' x 44''. Collection Mr. and Mrs. Larry Goldsmith. If I asked people which of the two men holds the most interest for them, three out of four would probably choose the one on the left. This only proves that profiles or semi-back views can hold great interest if you have the right sitter to paint.

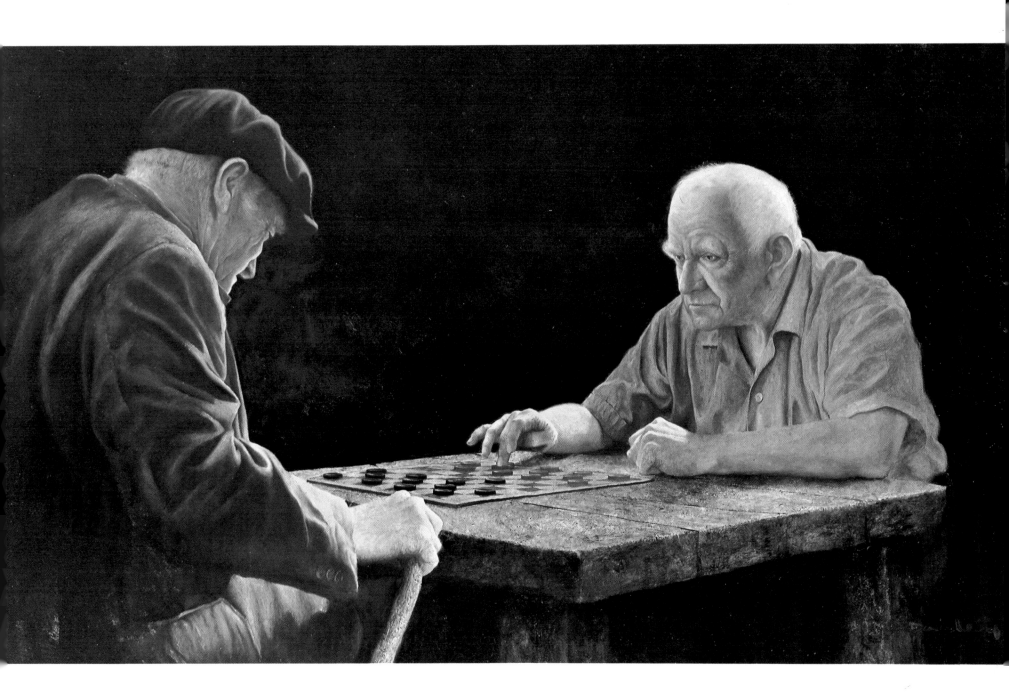

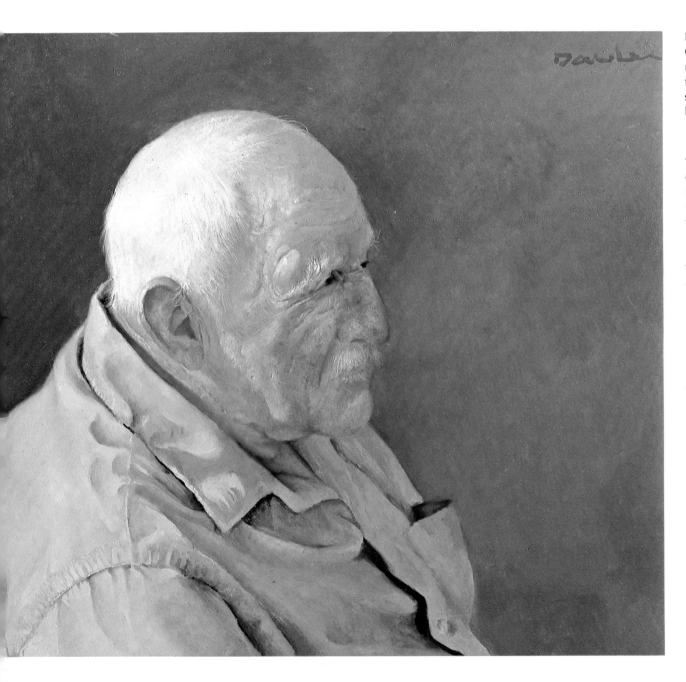

10

Head Study, (Left) oil on Masonite, 17″ x 24″. Collection Mr. and Mrs. Milton Gelman. The dramatic lighting used here emphasizes an unusual focal point for a portrait — the ear. Notice the cool shadow that the ear casts across his face. The ear can be an interesting feature if it's painted with care.

The Secret, (Right) oil on Masonite, 30″ x 40″. Collection Mr. and Mrs. Paul Sullivan. Note the importance of the partially hidden face of the old man who's telling the secret; his face complements that of the listener. The barrel was painted from imagination. I almost always make up my woodwork, because the feeling of wood requires so much texture that I prefer not to be restricted by copying an actual wooden object.

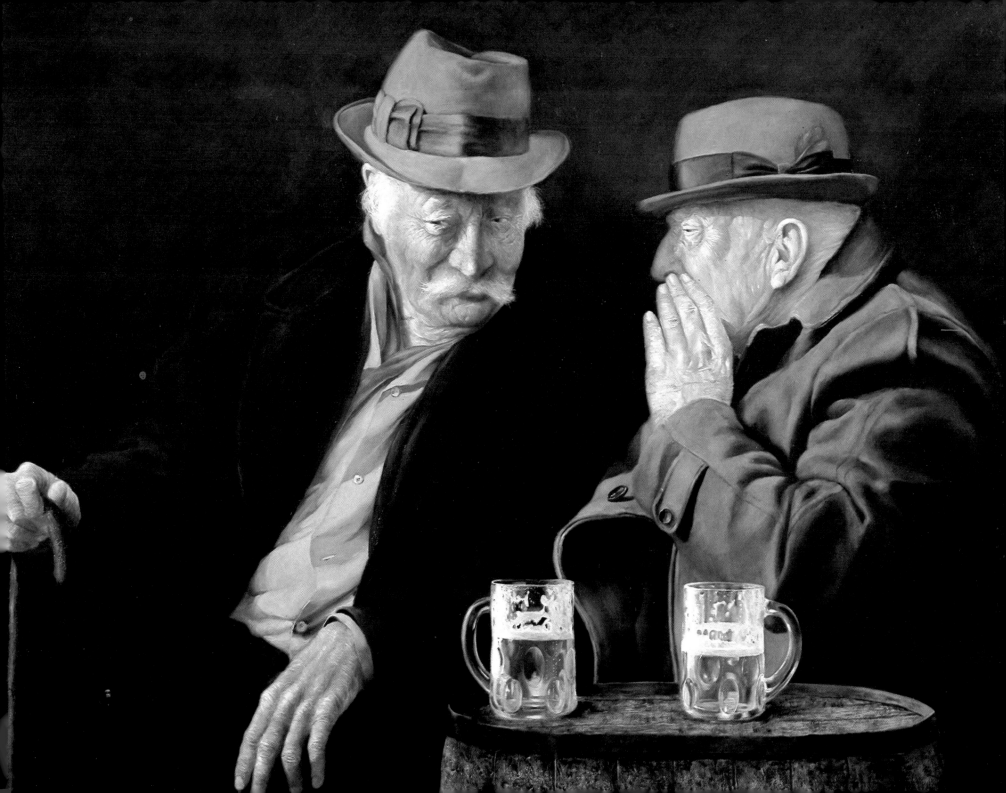

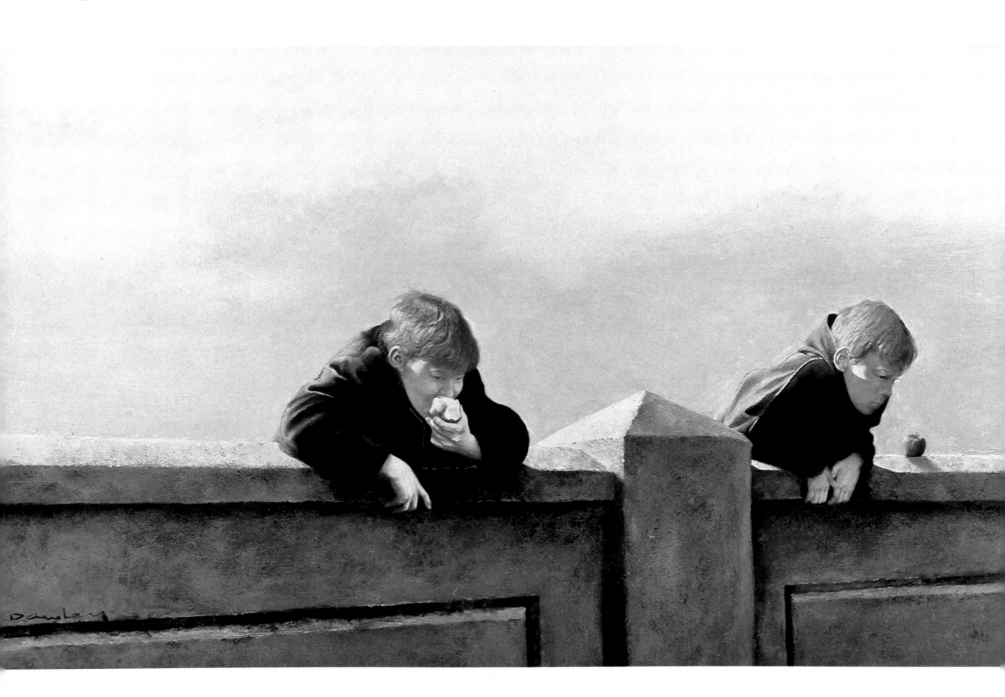

The Boys on the Bridge, (Left) oil on board, 24'' x 40''. Collection Mr. and Mrs. Joseph Schechterman. What is more nostalgic than boyhood? This simple act of companions stopping to gaze from a bridge evokes memories of everyone's childhood. The way the boy is biting contentedly into his apple is also an important element. I used the expanse of sky to suggest the closeness of nature.

Girl with the Apple, (Right) oil on Masonite, 30'' x 26''. Collection Mr. and Mrs. Raymond Zeltner. I've purposely elongated this young woman's fingers to emphasize their delicacy. The background was painted dark so that the unimportant details could become lost in it. This background also makes the lighting more dramatic, and the colors on the figure seem more beautiful against these dark tones.

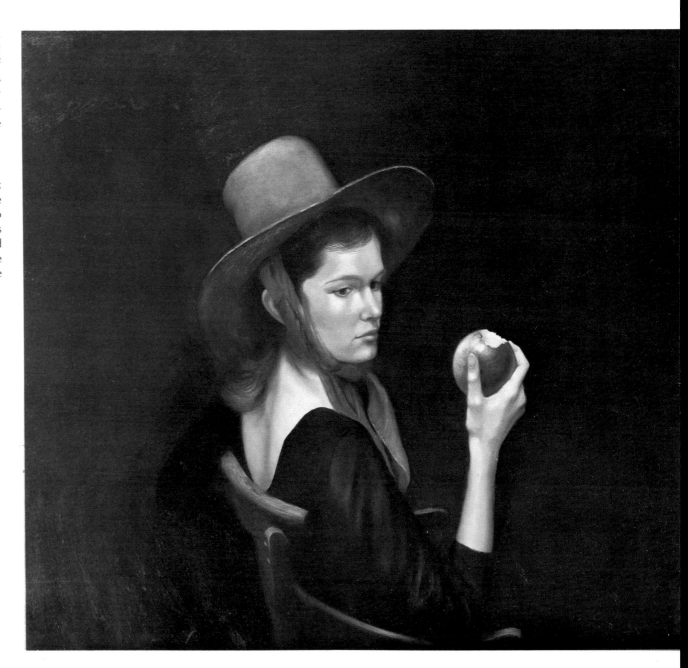

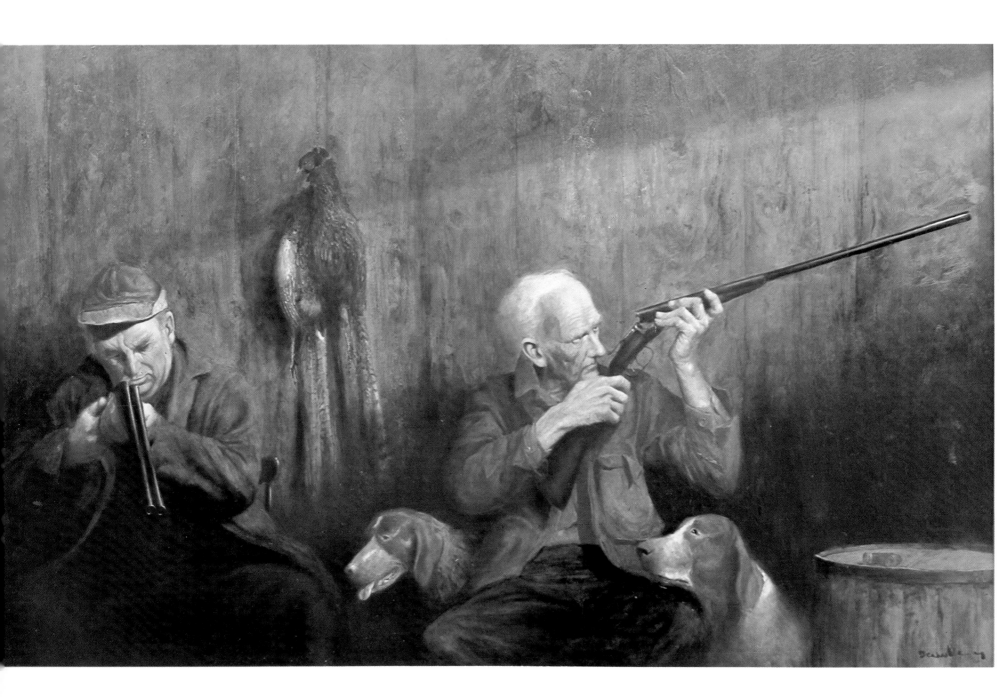

The Hunters, (Left) oil on Masonite, 28" x 48". Collection Mr. and Mrs. J. P. Awalt. Light streaming through the window creates a dramatic effect, spotlighting those elements of the painting on which it falls. The faces of the two figures are emphasized with this lighting arrangement while the lower parts of their bodies, not in the direct beam of light, are "lost" in shadow.

Peeling the Apple, (Right) oil on Masonite, 24" x 30". Collection Mr. and Mrs. Harold Kent. In this study I was trying to project the disciplined preciseness of an old man peeling an apple. The background was painted dark. His clothes fade into this background focusing attention onto the man himself as well as the bright red apple.

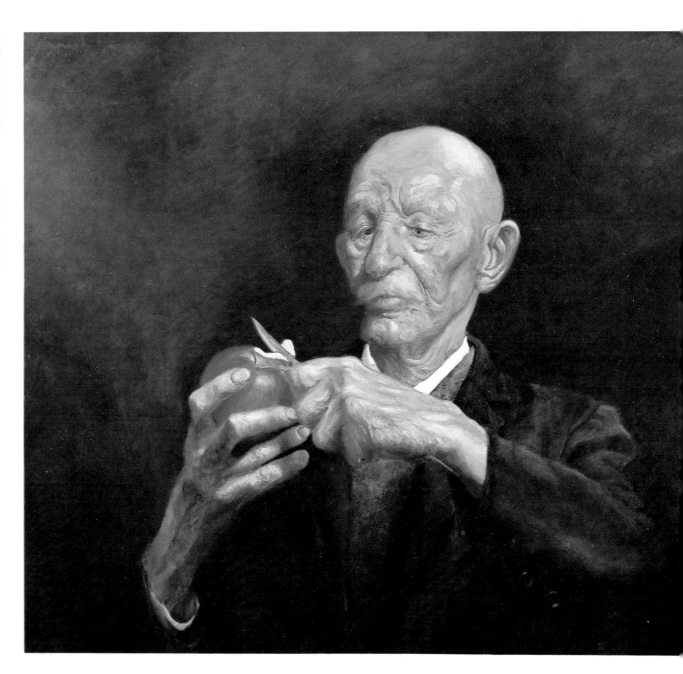

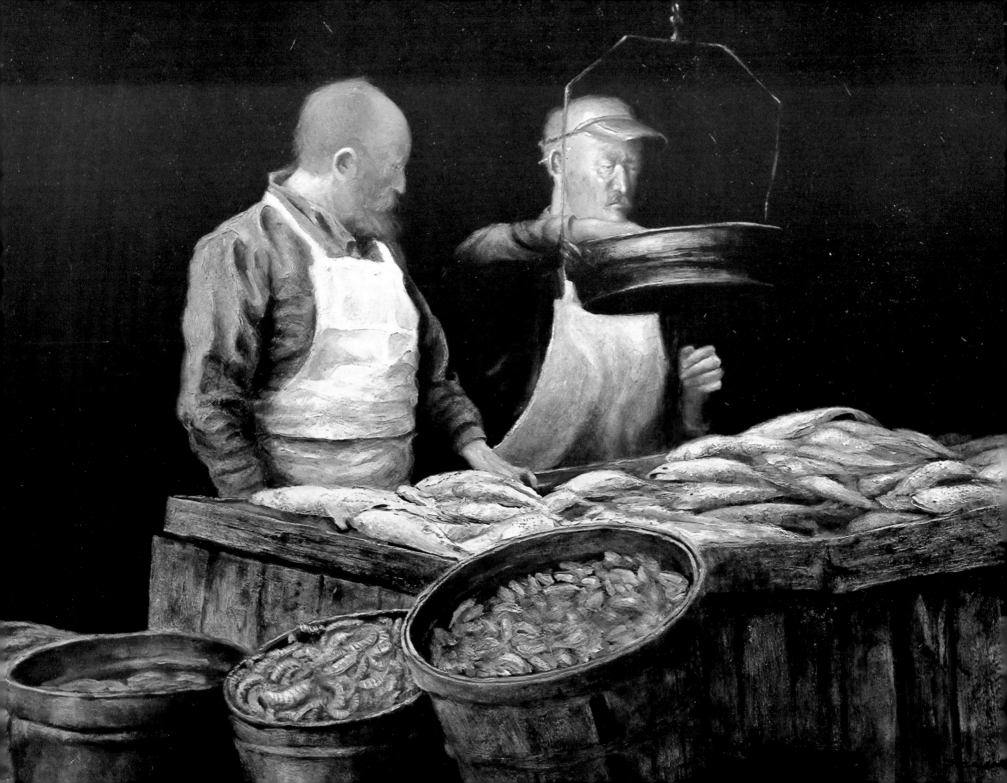

INTRODUCTION

The Fishmarket, oil on Masonite, 17″ x 24″. Collection Mr. and Mrs. Josef Schechterman. The soiled, white aprons, the dark background, and the different species of fish gave me all the color I could possibly desire. I payed careful attention to the abstract shapes inherent in the scene to create the overall design I wanted.

Painting is a mixture of poetry and craft, or technique. To me it's the link between the intellectual — the cerebral man — and the man who works with his hands. I feel that character painting is the most interesting. The history of art bears me out. Look at the "greats" — Rembrandt, Vermeer, Michelangelo, Velasquez, Titian, Hals — who've worked in this genre. Hopefully, this book will give you a better understanding of this type of art.

I don't really paint in steps, as I've done in the projects of this book, and I don't expect others to do so. This method simply offers an interesting and intelligible mode of explanation.

However, I don't wish this to be just a textbook — a handbook for artists. It can and should be utilized by anyone interested in art as a guide toward a better understanding and appreciation of character painting. This knowledge and understanding should enable the layman to enjoy and judge more accurately the quality and value of the vast amount of art available today. The misconstrued values and bad taste found in much of today's art do not stem from our advanced technological age, as so many believe, but from a plain ignorance of what constitutes a good painting.

I don't think many people truly appreciate the great accomplishments of the Renaissance masters. If they did, they wouldn't always be frantically searching for "something new" in art. Instead of constantly seeking the new, we should look to the old masters and their methods for inspiration and keep building upon their discoveries.

MATERIALS AND METHODS

No two artists use the same palette of colors or the same selection of brushes. When you try the projects in this book, you'll find my own palette useful, although you may have favorite colors of your own. You may already be accustomed to your own selection of brushes and other tools, so there's no need to rush out and invest in new ones, unless you really want to. In any case, here's what I work with, plus some notes on my painting methods.

ADVANCED PAINTER'S PALETTE

The following list contains, in my opinion, the best and the most permanent colors for producing skin tones:

titanium white	raw umber
Venetian red	raw sienna
burnt sienna	ivory black
yellow ochre	lamp black

Winsor & Newton's Venetian red is my favorite. The genuine iron oxide Venetian red supposedly isn't as permanent. If Venetian red isn't bright enough for you, use Mars red. I use two or three different brands of raw umber; they vary in color. I use ivory black with white to produce my grays, but sometimes I mix in a little raw umber. I use lamp black for very thin glazes, but ivory black is also good for this. For some shadow areas, I mix burnt sienna, yellow ochre, and ivory black.

ALTERNATE PALETTE

The colors of the preceding palette require a tremendous amount of practice to handle properly. Therefore, I've also come up with an alternate palette which will be easier for the student and may even be better for most advanced artists.

titanium white	burnt sienna
alizarin crimson	yellow ochre
cadmium red medium	ivory black
cadmium red deep	phthalocyanine blue

I use "phthalo" blue with yellow ochre and burnt sienna to create warm or cool shadows on the skin. I use it very sparingly because it's a powerful color. All of the colors in this alternate palette can be mixed with the first palette to give you an even wider range.

However, I wouldn't increase my number of colors past this point, because it becomes increasingly difficult to maintain good color relationship, which is so important to a painting.

PAINTING MEDIUMS

As it comes from the tube, color is usually too stiff and needs to be thinned with a painting medium to achieve the proper consistency for brushing. My painting medium consists of one ounce of damar varnish, one ounce of stand oil, four to four and one half ounces of turpentine, and two to five drops of cobalt drier. I use Singapore No. 1 damar crystals and melt them down in turpentine to produce the varnish used in this recipe. This is probably unnecessary, but I do it so that I can create what's termed damar varnish "five-pound cut."

I also buy turpentine by the gallon. Good quality gum turpentine is just as good as the so-called artist's rectified turpentine which is outrageously priced and sometimes causes the artist to skimp on turpentine. I usually place about six ounces of turpentine in a large-mouth jar.

It's very important to keep brushes clean. For example, if a brush containing a minute bit of raw umber is dipped into a bright skin tone, the skin tone will dull slightly; you'll wonder why you can't seem to get the desired colors. When turpentine becomes dirty enough to muddy your colors, even slightly, throw it out.

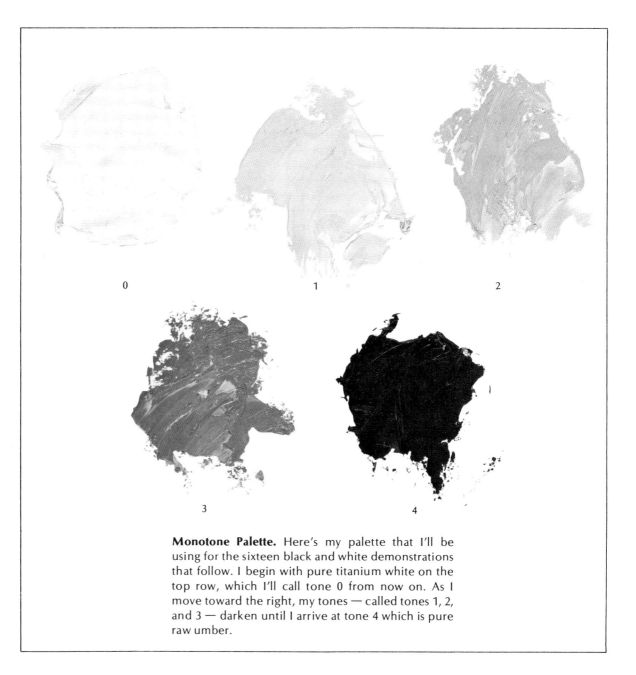

Monotone Palette. Here's my palette that I'll be using for the sixteen black and white demonstrations that follow. I begin with pure titanium white on the top row, which I'll call tone 0 from now on. As I move toward the right, my tones — called tones 1, 2, and 3 — darken until I arrive at tone 4 which is pure raw umber.

TINTING AND GLAZING COLORS

You've probably discovered that some tube colors are more transparent than others or turn transparent when you thin them with painting medium; these are the glazing colors. There are also a number of opaque colors that lend themselves particularly well to thin subtle veils, ideal for tinting. The following list of colors combines these two categories:

burnt sienna	cobalt blue
burnt umber	rose madder genuine
raw umber	raw sienna
ivory or lamp black	Mars yellow
cobalt yellow	titanium white

Rose madder genuine is a very expensive color, but it's supposedly far more durable than alizarin when used in thin glazes or tints.

TINTING AND GLAZING TECHNIQUES

After a painting is dry, you can brush painting medium over its entire surface. Then, you can add the same painting medium to a particular color and make minor changes in the skin tones that you find are incorrect. *Glazing* means that you're merely brushing on a transparent or semi-transparent color (such as raw or burnt umber) to achieve a little more luminosity, translucence, etc. *Tinting* requires the same process but you use an opaque color, such as a mixture of burnt sienna and titanium white or ivory black and white.

When tinting, you're actually changing color by completely covering one color with another.

When glazing, you're changing color by brushing a transparent color over one that has already dried; this allows the original color to show through, such as raw umber painted thinly over yellow ochre. The more painting medium you use, the thinner the glaze you'll produce.

BRUSHES AND PALETTES

For regular work, I generally use from 1/4" to 5/8" brushes; either bristle or sable. For tinting and glazing I use sable brushes. For backgrounds I sometimes get up as high as a 1" brush. I use a No. 2 or 3 watercolor sable brush (short handle) of good quality for detail work, such as the white highlights that often appear on the pupil of the eye. I scorn the long-handled detail sable brushes made for oil painting. They seem awkward and just plain stupid to me. They're also inferior in quality.

I use tear-away paper palettes which are available in most art stores. They're convenient, because they require no cleaning. Wooden palettes require cleaning after every use.

SURFACES

Stretched canvas is good if prepared correctly with top grade linen. Other books go into detail on this and since I seldom use it, I'll leave this subject alone.

Masonite brand hardboard is my favorite painting surface. It's probably superior to the wood panels that the old masters used. The board consists of wood chips exploded under great pressure to produce a binding fusion; only a small amount of resin is added for waterproofing purposes. I use only standard untempered board. Tempered Masonite will be all right except that you can expect the eventual darkening of your colors (similar to the effects of an old varnish). However, they'll eventually stop darkening, because it's only the tung oil used to produce this tempered surface that causes the colors to darken.

PREPARING MASONITE BRAND HARDBOARD

There are several good ways to prepare the board:

1. Apply several thin, smooth coats of acrylic gesso (the most generally accepted way).

2. I personally believe a better method is to thin down Underpainting White (a good quality brand) with turpentine, and rub it into the board with a rag, producing a very thin coat. The board will show through this thin layer of white. This produces an oil base for oil paint.

3. Dust the board off well, making sure it's clean; then paint right onto it. Do not use this method unless you use thin painting medium or turpentine as you start to paint, because there won't be enough adhesion. If this precaution isn't taken the paint may eventually flake off.

This method works very well for some people. I've never known a painting done on such board to crack, darken, etc. With a professional chemist, and on my own, I've tested Masonite panels which have been painted onto directly with oil paint. From the results, there's every reason to believe that this is a very durable

method. However, there's one tremendous drawback. The paint becomes very tacky, dries extremely fast, and pulls from the minute you start applying it to the board. Some artists may actually like this. Most will probably find it annoying and use one of the other methods of preparing the board.

Masonite has withstood every test possible and proved to be the most permanent of materials for the artists' use, provided it's sealed off properly on its back and sides. I apply acrylic gesso to its back and then allow the board to sit in a warm dry room for weeks before I use it. When my painting is finished, I seal off its sides with raw umber. Your painting should be tacked properly in a frame and supported in some way (cradling preferably) to avoid warpage if it's over 40'' in any direction. You should paste paper over the back of the frame to shut out any moisture.

VARNISHING

Basically there are two kinds of varnish: retouching varnish and final picture varnish. *Retouching varnish* is very thin, and its main function is to heighten color, not to provide a protective layer on the painting's surface. You can apply retouching varnish as soon as the painting is dry. *Picture finishing varnish*, on the other hand, is thicker and forms a durable coat that protects a finished painting from air pollution, scratches, and dirty hands. This varnish is applied several months after the painting is completed and dry all the way through.

I use a good quality retouching varnish, spray-ing on two or three thin coats. After eight months I feel that it's safe to use a permanent damar picture finishing varnish. If my paintings were done on a surface other than Masonite brand hardboard (say, stretched canvas) they'd require much longer to dry and, therefore, more time would have to be allowed before applying the varnish.

TONAL VALUES

The following sixteen demonstrations are exercises done in monotone oil paint which appear to you as black and white. I've always preferred to do these exercises with raw umber and white. I use more oil paint than I need and suggest you do the same. It's better to throw away a little paint than to keep mixing and matching tonal values. I lay out on my palette a range of five tones. My favorite white is titanium. I refer to this pure white as tone 0; tone 1 is about 95% white and 5% raw umber; tone 2 is about 90% white, 10% raw umber; tone 3 about 75% white, 25% raw umber; and tone 4 is pure raw umber from the tube.

I suggest that you lay out this palette and then copy each demonstration straight from the book. Then get a friend to sit for you and try using his eyes, ears, nose, or mouth as exercises. In this way you'll become familiar with the individual features. If you do them well, don't throw them away; keep them for reference. By doing single features, you'll be able to give them more attention than you would if you were painting a complete head, and they'll come in handy. Try to do each feature about lifesize.

However, after doing the single feature exercises, you must remember that in a regular painting you will *not* single out each feature and paint it as a separate unit. These exercises are to familiarize you with areas of the head and hands and to help you gain confidence.

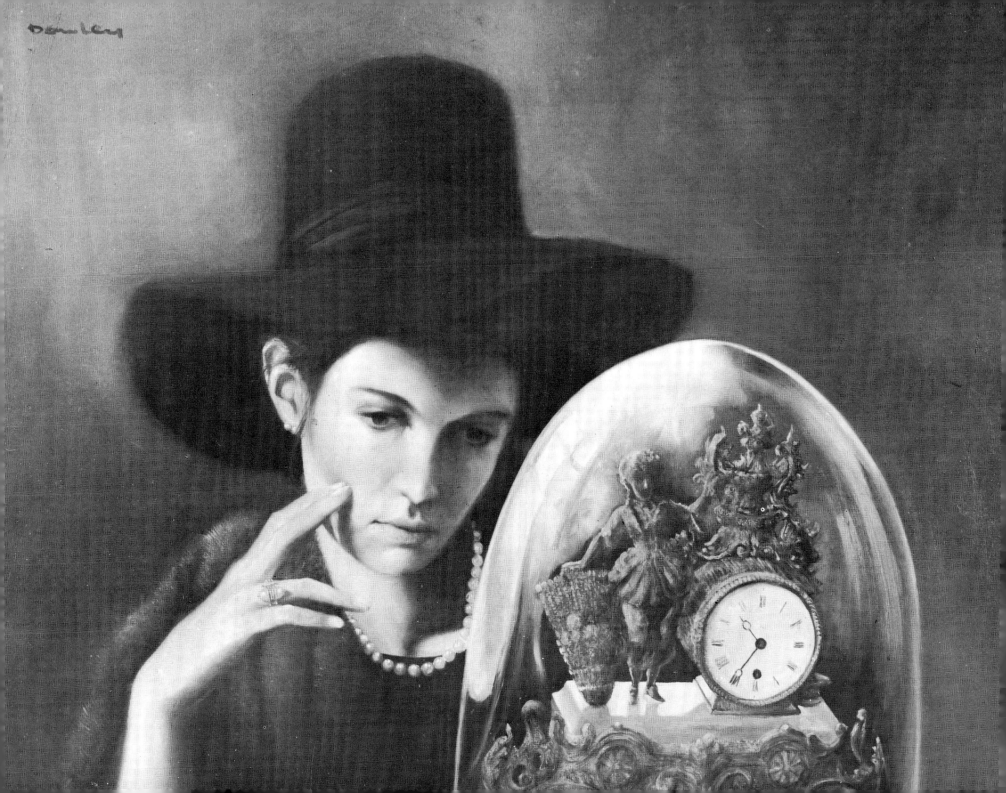

DEMONSTRATION 1: **THE EYE**

Woman with the Clock, oil on Masonite, 20″ x 24″. Collection of the artist. The pensive expression on the young woman's face can be interpreted by the viewer in an infinite number of ways. What is she thinking? Note that the elegance of the clock is carried through in the elegant attire of the model.

The eye isn't a separate entity to be handled alone, but a vital part of the overall portrait. The eyes must blend with and complement all the other elements that together create the finished portrait. The mood conveyed by the eyes should either carry or complement the rest of the painting, but the eyes mustn't stand simply as a point of interest.

There are an infinite number of moods and impressions enhanced or created by the eyes. Eyes can be dominating and dynamic like those that seem to follow you wherever you are in a room. Eyes can flash; they can be saucy, serene, studious, *ad infinitum*. They're an invaluable aid for guiding your viewer's eye along a certain pattern within the painting. Remember that the direction in which your sitter's eyes are gazing will determine the direction of the viewer's gaze.

Any painting advances as a whole — as an entity. So follow the steps of this demonstration only in relation to where you are with all the other areas of your portrait. Don't handle the features separately; don't complete an eye until all the other features are ready for the final touches. Progress at the same level of completion throughout. Also, you should normally work on both eyes at the same time to insure their relationship to each other, thereby maintaining unity.

The eye is somewhat almond-shaped. Of course, this general shape is subject to infinite variations. Therefore, it's imperative that you carefully note the general shape and characteristics of your sitter's eyes. Each person's eyes will naturally be different, and the expressiveness of his eyes will be a constant variable also. The roundness or flatness of the eyeball itself should also be considered. The shape of the eyeball will affect the depth of the shadow created by this curvature and will further determine the amount of tone necessary to recreate this shadow.

Keep in mind that women appear to have more eyelashes than men. Even if eyelashes aren't apparent in the woman you're painting, add them to create a more pleasing effect.

The Eye: Step 1. In this step, I'm concerned with establishing a rough approximation of the eye. I must render the general shape and location of all areas of the eye. At the same time I must also give an indication of the varying degrees of tonal values present on the eye and eyebrow.

In this step, tone 1 is used exclusively to draw this eye, but the manner in which I use it will let me place the light and dark areas where I want them.

I drag tone 1, thinned with turpentine, around all the dark shadow areas of the eye. This includes the eyebrow, the large shadows at either end of the brow, the lids, the pupil, and the crease appearing above the upper lid.

Now I take my brush and apply tone 1 unthinned to the thick portion of the eyebrow. I apply it also to area B, the pupil, the lids, and the crease above the upper lid. Now, I've painted an eye and indicated the light, medium, and dark areas with which I'll be dealing later.

The Eye: Step 2. During this step, I'll be separating the light and dark areas properly to gain the initial appearance of the eye.

I start with tone 2 and block in the iris. I lighten tone 1 with white and block in the white of the eye. Be careful not to get the white of the eye too white; it gives way to an amateurish final appearance. I lighten tone 1 again, a little lighter than before, and brush in the exposed top of the mucous membrane area which is just above the lower lash line.

With tone 1, I block in the upper lid and area A. I paint the upper lash and pupil in with tone 3. Don't try to be too precise with the pupil; at this point just give a rough idea of its location.

The eye used in this demonstration is a right eye. The light source is coming from the sitter's left, so shadows will fall from left to right. The source of light is always an important factor, since the shadow areas of eyes and other features will be determined by it.

Bear this in mind as you follow these instructions.

With tone 2, I fill in shadow area B, blending toward the lighter tone at the center of the curve over the eyeball. This is a form shadow — appearing on the object's surface, caused by the object's rounded shape — as opposed to a cast shadow — produced by an object and falling onto the surface of another plane or object — and necessitates the blending mentioned. This blending isn't required with a cast shadow.

A cast shadow falls under the outer edge of the upper lash and is filled in with tone 2. This shadow also extends partially along the lower lid. Tone 3 is used for the darker lash line of the upper lid on either side of the pupil. I use tone 2 for the line at the upper rim of the socket, referred to as area C. Tone 2 is also used for the eyebrow and the shadow areas that appear where the nose and eye blend together.

The Eye: Step 3. During this stage, I start defining what's already present. I carefully check the eye's shape and positioning before I proceed. What's present at the end of step 2 constitutes the entire foundation on which I'll build. Therefore, the existing light and dark tones should be fairly accurate in both their location and value.

I start looking for the light areas of the eye. I blend in white at the top of the lower lid in the mucous membrane area. Be sure to blend it with the paint that's there; don't just lay it on. With white and tone 1 combined, I brush in the highlight between the bridge of the nose and the corner of the eye in area D. I whiten the white of the eye a little more, but again I don't go overboard. I add a mild highlight to the pinkish inner corner of the eye. I place tone 1 in the lighted areas of the upper lid and above, referred to as area A. I blend this carefully in both areas to achieve for the first time a somewhat rounded eye-in-the-socket appearance.

Now for the strongly highlighted areas. For a strong highlight, I touch the pink inner corner of the eye

with white. I drag my brush so that it blends slightly with the paint I've put in earlier. I take a small brush and place white paint where a highlight appears on the mucous membrane of the lower lid.

Finally, with a small brush and tone 1, I lightly follow within the iris part-way around the outer edge of the pupil. At this point, the eye should not only have a rounded effect, but the iris and pupil should also have a glassy appearance.

The Eye: Step 4. I'm now in the final stages of refining and defining the eye. The most important task here is to blend and refine very carefully.

For the eyeball itself, I retain the light tone in the white of the eye next to the iris but blend slightly darker tones outward toward the extremities of the white; these darker tones will give form to the eyeball. I refine the iris with the darkest area again at the outer rim, blending carefully into the lightest area next to the pupil. I refine the pupil itself, if necessary, working for its correct value. Refer to Demonstration 2, step 4 for acquiring a translucent effect in the iris.

To complete the eyelashes, I first complete the upper lashes by defining them with tone 4. To avoid harshness, I carefully blend tone 3 with a small brush directly above tone 4, but below the lid. To complete the lower lashes, I flick them in carefully, but casually, with a small brush. This may sound contradictory, but I want to achieve the visual impression of the lower lashes without the appearance of each lash having been painted in.

Now, I define the eyebrow, keeping it darker at both edges than in the center. This trick enables me to have an eyebrow without harshness; one that appears real rather than painted on. I define and darken the shadow in the nose cavity.

Finally, you'll note that I've painted a slight bag under this eye. The bag was there — they often are — and the degree of emphasis with which you portray them is up to you.

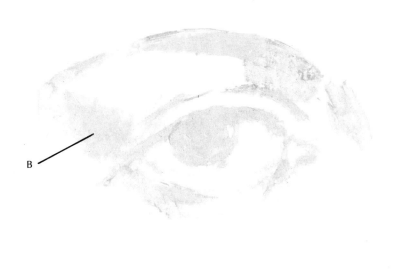

1

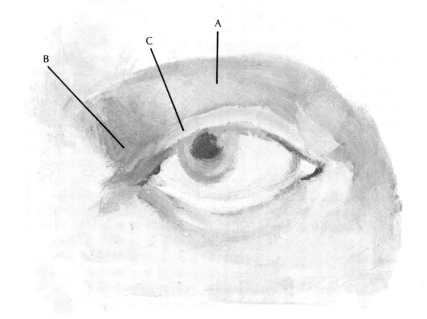

2

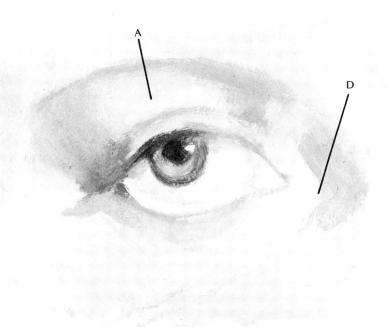

3

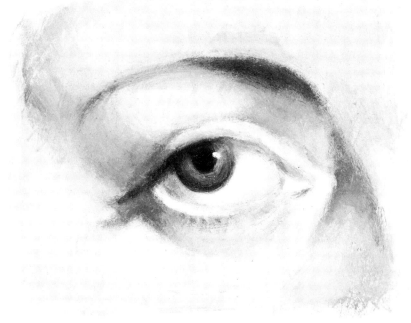

4

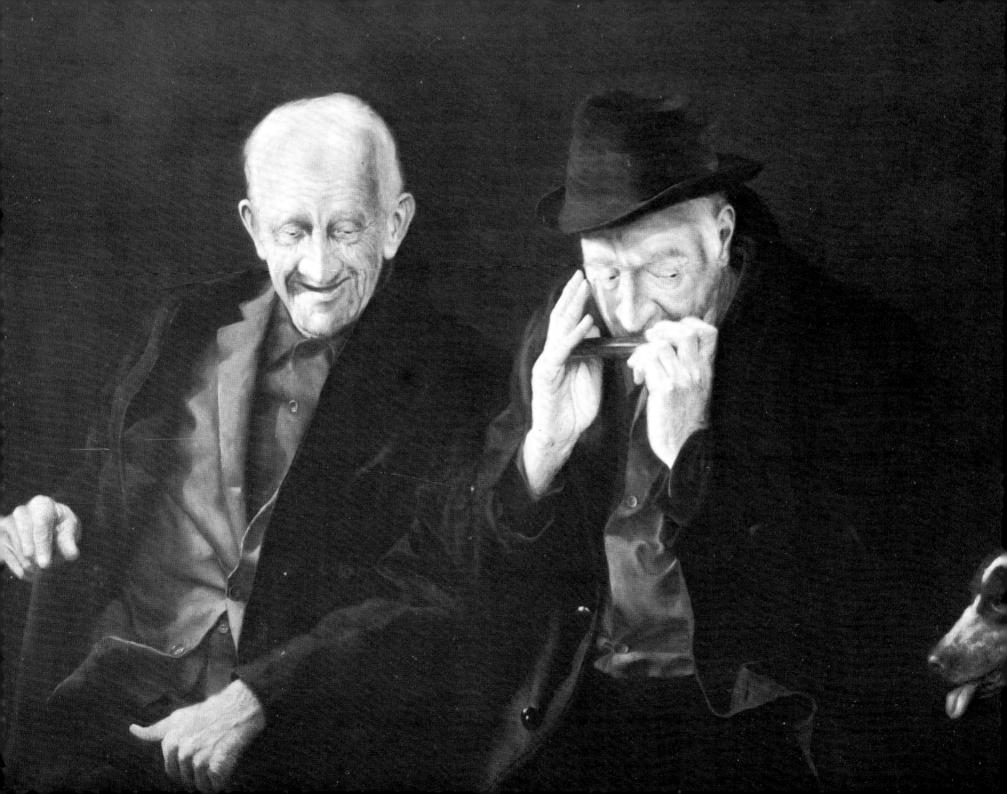

DEMONSTRATION 2: **THE EYE IN OLD AGE**

Old John Serenading His Dog, oil on Masonite, 35" x 50". Collection Columbus Museum of Arts and Crafts, Inc. Gift of D. A. Turner. Compare this "harmonica" painting to the one on page 40. The happy mood here is a contrast to the rather forlorn one of the other painting. It's not John's mood but that of his companion on the left that creates the cheerful atmosphere. Even John's dog has a bit of a smile.

Old eyes are as interesting to paint as they are to view. Eyes in general are very expressive, and old eyes have had just that much longer to develop all their potential interest and expressiveness.

Over the years interesting personality quirks may manifest themselves through eye movements. Thus, through repetitive use of the same eye muscles, you'll find excessive laugh lines, a chronic look of wide-eyed surprise, a tired expression, or even overwhelming sadness. These are only a few of the most apparent emotions old eyes can convey. I'm being very general; in many old people their eyes merely age, revealing anything you may want to read into them.

All tissue loses its elasticity with age, and the eyes often are the first area to display this loss. Wrinkles appear around the eyes; ultimately the lids become loose flaps of skin and develop a drooping effect. This droop is so characteristic that it's invariably involved in your renderings. But when selecting your subject, be careful that the droop isn't so pronounced as to nearly obscure the eyes. When this happens, you'll have to call upon your skill to widen the eye.

It's better, therefore, to avoid this situation, but I realize that sometimes that's impossible.

Your use of highlights will be different when rendering old eyes; they lack the luster that young eyes have. They may display a charming twinkle, but the sparkle of youth has gone, so watch those bright highlights. As a matter of fact, the highlight on the pupil often isn't present at all. If the eye's droop is quite pronounced, its pupil will be in shadow, thereby eliminating this highlight altogether.

Lastly, old eyes are often set deep in the sockets, producing an almost wall-eyed appearance. This requires more work in the socket area to properly render these shadows.

You probably won't be too pleased with the results of these old eyes out of context. Alone, old eyes aren't that interesting, but combined with other old features in a face, they're a magnificent testimony to the beauty of old people.

28

The Eye in Old Age: Step 1. I capture the general outline of the eye with thinned tone 1. This includes the lids, the pupil, the bags, and the shadows. To accentuate the dark shadows and the pupil, I come back in with tone 2 in full strength.

The eye used here is a left eye, gazing in the direction of the sitter's nose. The light source is from the sitter's left, so that the deepest shadows will be falling on the right by his nose.

The uppermost line in this rendering represents the edge of the socket. I extend beyond this in steps 3 and 4 to give a sense of relationship, but for now this is all that's necessary.

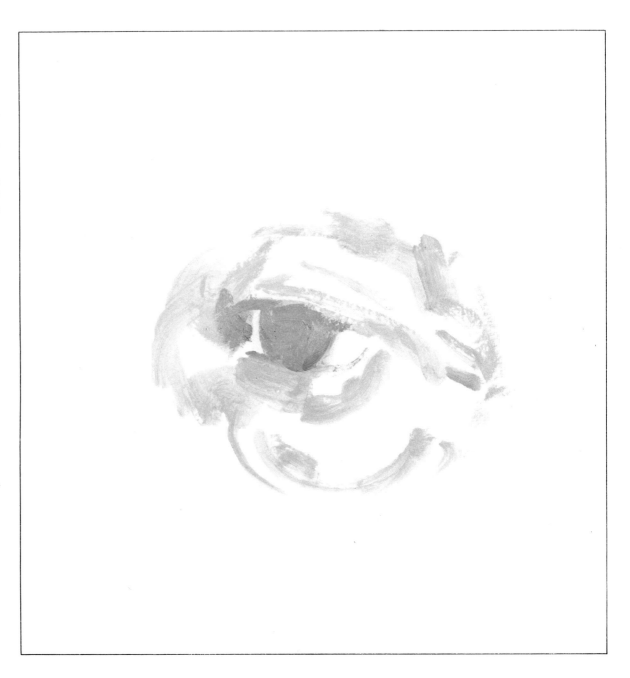

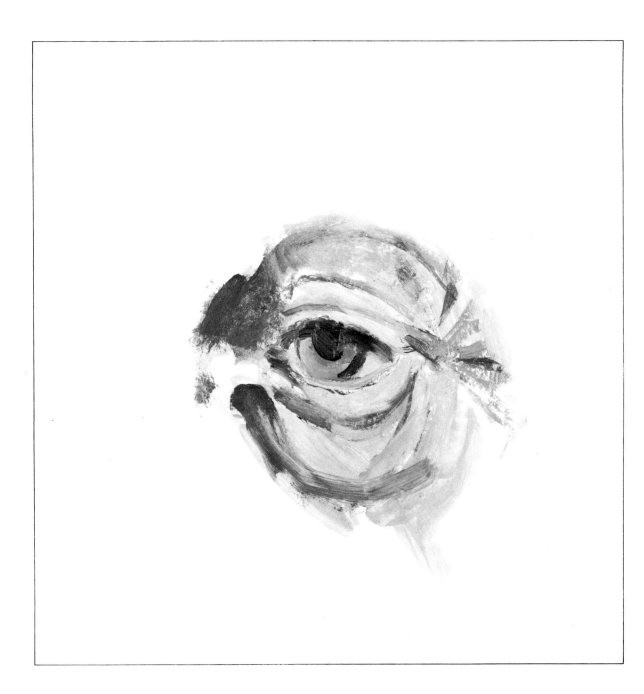

The Eye in Old Age: Step 2. I fill in the skin tones of the upper lid with tone 1 and lay in the two creases with tone 3. I lay in wrinkles at the outer corner of the eye with tones 2 and 3. The skin tone under the eye is also indicated with tone 1 and the bags are indicated with bold strokes of tone 3. Tone 3 is also used to depict the large shadow on side A, where the eye approaches the nose.

The eyeball itself undergoes dramatic changes in this step. I start by filling in the white of the eye with tone 1, being careful that it's not too light. The white seems frequently darker in old eyes. I come in with a rounded stroke of tone 1 for the iris, leaving a dark line of tone 2 for the darker, outer edge of the iris. This one stroke will suddenly produce the pupil, as well as the light and darker tones of the iris. I accentuate the location of the pupil by applying tones 3 and 4.

Under the lower edge of the upper lid a shadow is cast on the eyeball. I use tone 3 for it. Finally, I place a dab of tone 3 in the inner corner of the eye.

The Eye in Old Age: Step 3. As depth and dimension develop, the aged appearance of the eye begins to unfold. At this point I expand my rendering above the upper edge of the socket. The edge of the socket remains dark to depict the shadow there, and then lightens gradually as I expand above that. This enables me to produce the appearance of the eye protruding from its socket in a bulging manner, as so often happens in old age.

The upper lid is blended slightly; the various tones — 1, 2 and 3 — are maintained. The lightest areas of this segment are toward the left side of the sitter's eye where the light hits, becoming darker as the lid rounds over the eyeball into the shadow by the nose. I lay in tone 3 for the large shadow A and brush it into the lid for the dark side of the form shadow. The large area of this shadow, toward the nose, is left in its unblended form for the moment, because it's a cast shadow at that point.

Tone 3 is brushed into the light area of the iris; tone 4 is brushed into the pupil. The white of the eye appears a bit too dark, so I lighten it slightly with tone 0 and then define the lower lid with a very thin line of tone 3, because the lid is more pronounced at the inner corner edge.

I use some slight blending on the bag area below the eye, retaining distinct strokes of tones 1, 2 and 3.

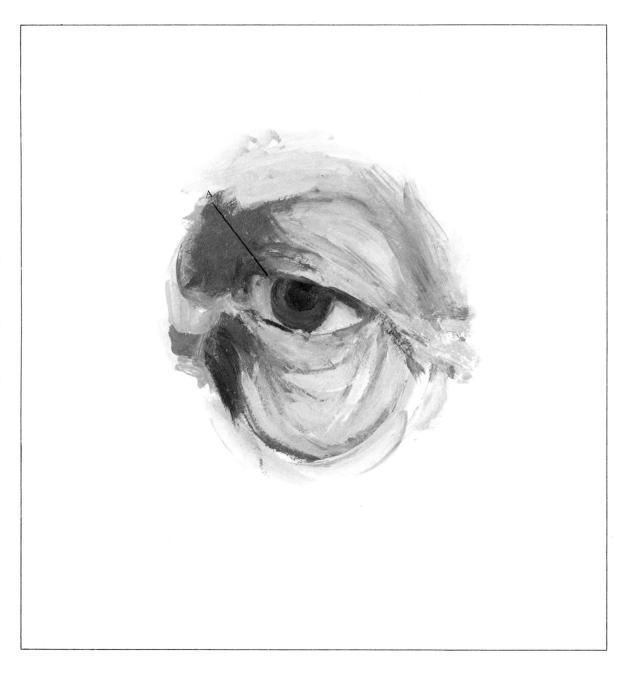

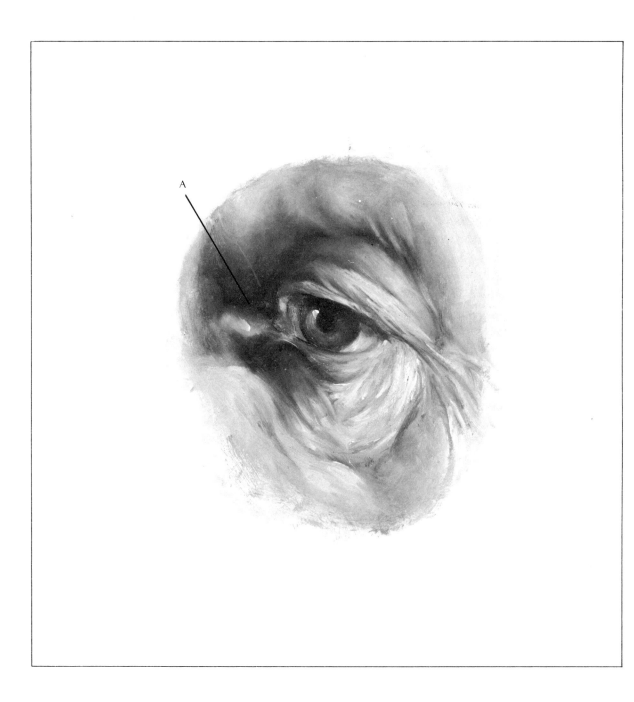

The Eye in Old Age: Step 4. Blending alone won't produce the desired aged appearance of this eye. You must blend and add additional brushed-on tones to capture the many folds and wrinkles that provide the eye's character.

Shadow A is blended completely upward and to the left over the eyelid. To define the socket at this point, I lay in tone 3 along the edge of the socket and blend to either side.

The folds in the lid are illustrated softly with tone 3 and blended slightly to avoid harshness. The lid is blended from the dark on the eye's right to the light on the eye's left to attain its form. Strokes of tone 1 and 2 are layed over this blending to represent the wrinkled skin.

Brushstrokes of tone 2 extend beyond the left corner and flow downward for the laugh lines. Thin lines are layed in with tone 0 alongside the laugh lines to give depth to these creases.

The lash line of the upper lid and the shadow directly below are carefully rendered with tone 4. The lid is thick, however, and as it rounds upward from the inner corner, the exposed mucous membrane is illustrated with tone 1. A thin line of tone 4 also represents the lower lash line.

I blend the area underneath the lower lash line from dark into light and then lay tones 1, 2 and 3 on top of this is a curving manner to represent the wrinkles. Tone 1 is used for the light area on the face directly beside the inner corner of the eye. A highlight is seen here, and I use a dab of tone 0 for it.

I give the iris its translucent look by laying in a sweep of tone 2 over tone 3 just below the pupil. A touch of white produces the highlight here. To give the iris real depth, I let the paint on the eye dry thoroughly. Then, I brush painting medium over the iris. I thin a small amount of tone 4 with painting medium and apply this ever so thinly over the iris, avoiding the white highlight. Excess may be removed with a clean brush.

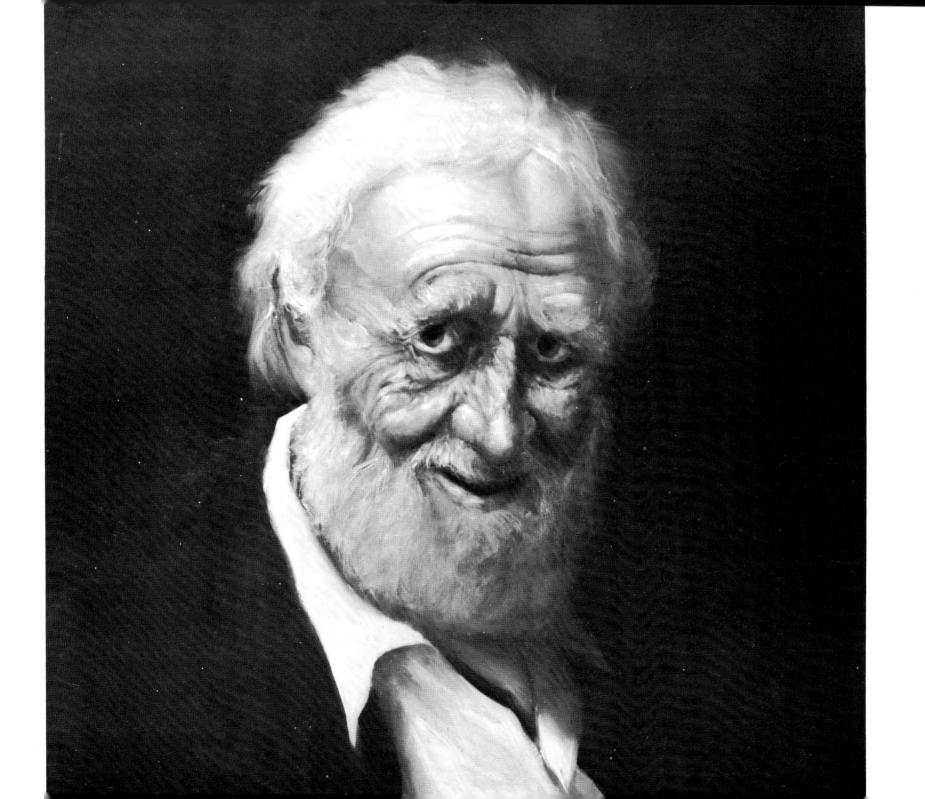

DEMONSTRATION 3: **THE NOSE**

Head Study, oil on Masonite, 17″ x 18″. Collection Mr. and Mrs. Ralph Brass. I've used a bold brushy technique to capture the weather-beaten quality of this old man's face. Head-on views such as this, where the eyes are looking straight at you, can be rendered quite convincingly in this rougher method.

Unfortunately there's nothing I can say about the nose to give it any glamour at all. It's there and must be approached with as much positive thinking as possible.

Because of its wide range of lengths, widths, and curvatures, combined with its very prominent location on the face, the nose is a very important ingredient in portraiture. It necessitates fine rendering and good judgment on your part. You must make it look as if it belongs with the other features. Actually, if a nose is wrong for your sitter's face, it will stand out and eventually be the only thing you see in the painting.

A poor nose will eventually become ludicrous and objectionable. It's up to you to avoid this situation by performing plastic surgery, so to speak, with your paintbrush. Notice, particularly in a man, that there's a definite difference between a nose that's unique and unusual and one that's obnoxious. In a woman, of course, your only goal can be that of an attractive nose.

Learn to be discerning; then work to correct the nose's flaw — whether it's length, width, or whatever — just enough to allow the nose to blend with the other features. With practice you'll be able to do this without disturbing the facial expression. By doing this, you'll not only have enhanced your sitter, but also given your portrait a fighting chance for success.

The Nose: Step 1. This head-on view of the nose seems a good one to choose not only for interest, but also because it offers good practice in creating a three-dimensional effect. This, of course, is most important in working with the nose; you certainly don't want to wind up with one that appears to lie flat against the face.

First, notice that the light is from the sitter's right, flooding that side of the nose with light. Therefore, I only sketch in the areas of the nose that are darker than this bright area, using the shadow areas to delineate form.

With tone 1, I fill in the light shadow areas down the left side of the bridge and around the outer edges of the nostrils. To indicate the nostrils themselves and the darker shadows, I use tone 2. The remainder of the nose is left to be completed during step 2.

The Nose: Step 2. Now I'm ready to completely fill in the nose and give it its rudimentary form and dimension.

The light, right-handed side of the nose is filled in with a combination of tones 0 and 1. If you look closely, however, you'll see that I haven't simply filled it in with flat color. Within this entire light area the very lightest spots and the slightly darker spots are appropriately indicated to create form and depth.

I use tone 1 and tone 2 to fill in the deeper shadows found elsewhere. As you can see, by the use of a very light tone on the tip of the nose and tone 1 placed underneath that, I'm able to indicate the tip, thus giving dimension even at this early stage. Tone 2 is used for the deep shadow found on the left side of the bridge where the nose and the face join. I don't do much blending now; this will come in later steps.

The Nose: Step 3. In this step I do a little blending and a great deal of refinement. The main concentration is on giving depth to what has been previously indicated.

I take tone 1 and lay it into the light area on the right side of the bridge, blending slightly with the paint already present. Tone 0 is also layed into the highlight area on the tip of the nose but not blended at this time.

Now I lay in the deep shadows. Tones 3 and 4 are combined in the long shadow extending down the left-hand side of the bridge. This shadow is deep as far down as the bulbous tip of the nose. In a milder form the shadow extends all the way to the bottom of the tip where the nose joins the face. For this milder shadow, I use a small amount of tone 3 and blend it. I use tone 4 for the deep shadow swinging clear around the left nostril.

The nostrils themselves are a series of shadows blending into each other. I work with tones 2, 3, and 4 as necessary to fill in the nostrils. Note that tone 3 is brushed out of the right nostril under the very bottom of the tip lying between the nostrils. This indicates a shadow which will be worked in later. Finally I work with tones 1 and 2 to fashion the exterior of the left nostril which needs to become more substantial.

The Nose: Step 4. In this final step I'll blend everything into its final softness. I've included something very important in this step which wasn't present before — the cleft which appears directly below the nose extending down to the mouth. I wish to include this portion to give you an indication of how the nose actually fits onto the face.

I blend the long shadow along the left side of the bridge — not only sideways into the face and the bridge, but also down along the left side of the nose's bulbous tip. This adds a great deal of depth and dimension to both the tip of the nose and the left nostril. The shadow extending around the exterior of the nostril is blended to flow into the overall shadow formations of the left side. I subtly blend a bit of tone 2 into the edge of the left nostril to show its form as the light hits it.

To accentuate the right nostril, I place a dab of tone 0 at its back and top almost on a parallel with the tip of the nose. Below this, where the exterior of the nostril fans out, I blend tone 1 dragging this tone around the upper outer perimeter of the nostril toward the very center point between the nostrils. This light area occurs because of the lighting conditions in this particular study. As a result of my light source, I use tones 0, 1, and 2 to capture the light underneath the right nostril.

The final highlights are my last consideration in this demonstration. I place a highlight on the bridge with tone 0, but I blend this slightly so that it isn't the brightest highlight. I place my brightest highlight on the tip of the nose as a final touch.

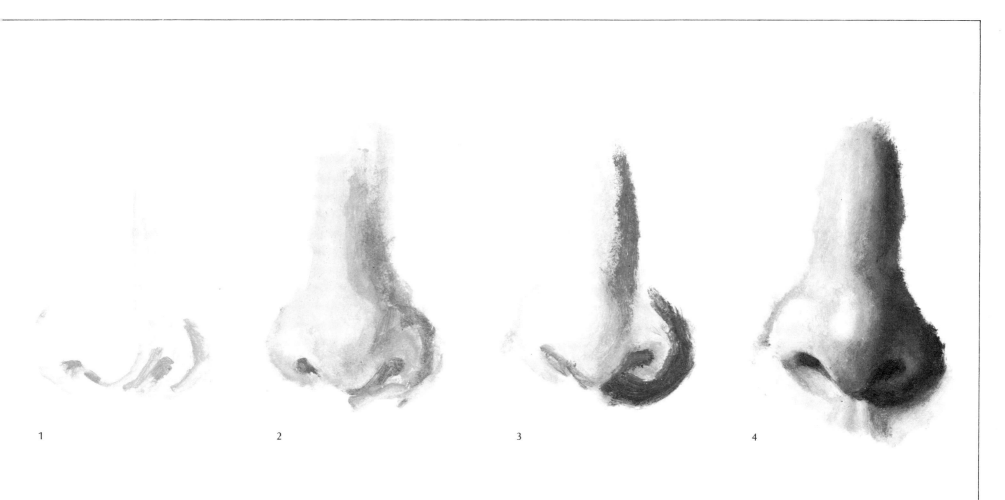

1 2 3 4

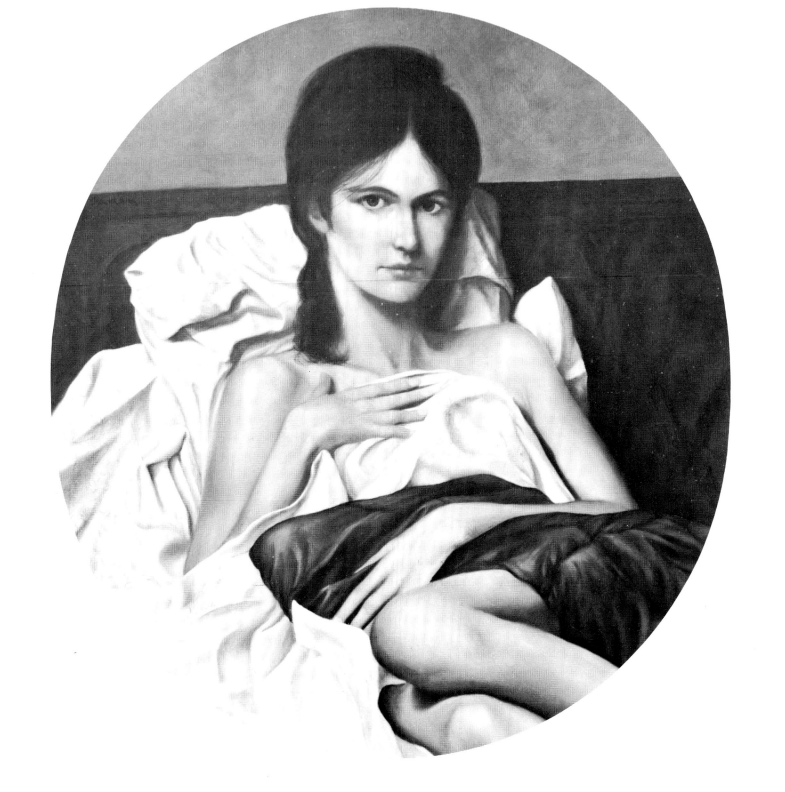

DEMONSTRATION 4: **THE MOUTH**

Girl in Bed, oil on Masonite, 25″ x 21″. Private Collection. This lovely young woman has a very enigmatic smile which creates a mysterious ambiance. Her mouth is the most important feature in this painting. The onlooker can read into her smile almost anything he wishes.

The mouth is undoubtedly one of the most intriguing and interesting human features. It's used to express the entire range of man's deepest and most cherished emotions — sensuousness, innocence, happiness, shyness, secretiveness, etc. This vast and intricate range of human emotions is perhaps more comprehensively expressed by the mouth than by any other single feature. This is due to its remarkable delicacy and its total mobility which aren't shared by other features.

Both the mouth and the eyes share great responsibility in visually conveying to the onlooker the inner emotions of the sitter. When someone speaks to you, you're constantly observing his eyes and mouth for meaning and expressiveness not conveyed by his words alone. In such cases, you're especially aware of the mouth.

The mouth's mobility which provides such a vast range of expression can also cause you

grief when you attempt to capture the exact expression of that mouth. For example, the difference between a sincere smile and an insincere one is so negligible that it often resides in knowledge of the sitter rather than in observation of him. However, the difference in feeling conveyed by each smile is enormous. The physiological difference between these smiles is created by some very minute muscular changes, hardly perceptible in themselves. What enormous changes then can be wrought by the slip of the brush?

All of this isn't intended to make you nervous, only aware of the problems at hand and the special care needed to render the mouth exactly as you want to portray it.

The Mouth: Step 1. I've deliberately chosen to paint a mouth at this slight side view rather than head-on. You'll seldom do a head-on study, because it's not as pleasing to view. Therefore, I'm presenting what you would most likely be faced with doing. However, if you should choose a head-on view, the same general instructions would apply with obvious changes in shadow areas, and it should present you with no major technical difficulties.

It seems both advisable and necessary to include slightly more in this demonstration than the mouth alone. Therefore, I'm including the entire upper lip, lower lip to the top of the chin, and a small area on either side of the mouth.

I begin by sketching the shape of the mouth with tone 1. Then, with tone 3 I give only the barest indication of the dark separation between the lips by adding this tone in its center and at its corner.

With tone 1, I lightly note the indentation of the upper lip directly above its center dip. I continue to place shadows with this tone at the corners of the mouth, under the lower lip, and on the upper lip to a small degree.

The Mouth: Step 2. Now, I'll be adding more form to the beginning sketch to get the mouth in a workable state. With tone 3, I darken the upper lip. In most cases involving ordinary lighting and posing conditions, you'll notice that the upper lip will be in shadow.

Tone 4 is used to expand the suggestion of the separating line between the lips. At this time the corners on both sides of the mouth are merely indicated with this same tone.

I fill in the bottom lip with tone 1. I'm now involved with indicating two form shadows appearing on the lower lip. You'll notice a crevice in the center of the lower lip which is in shadow. This form shadow is indicated with tone 2. A form shadow also is evident on the left side of the sitter's lower lip as it rounds into obscurity. Tone 2 is also used in this area.

I thin down tone 2 with turpentine and use this tone to denote the shadow area beyond the lips on the sitter's left. Tone 3 thinned with turpentine is used to denote the shadow area under the mouth. The mouth is now taking shape, and I'm ready to proceed to step 3.

The Mouth: Step 3. With a combination of tone 1 and white, I block in the highlighted skin areas above the upper lip, continuing down and around to the sitter's right side of the lower lip. As I do this, I soften the corner line of the mouth slightly.

I place a thin line of tone 3 under the existing line which denotes the lip separation. This is only laid in so that it can be used later for blending, thereby creating form.

The lower lip requires more roundness than it now has. You'll notice that the light source is obviously coming from the sitter's right to left which causes the lip to go quickly into shadow on its left side. To denote this, I brush in tone 3 carefully, blending it with the tone 1 already on the lip. I also want to show just to the left of this crevice the fast change from light to very dark on the far left. When I've done this accurately, I should have a fairly rounded lower lip.

Now I want to give the upper lip its shape. Notice that an upper lip dips to form a point in the direct center. Beginning at this point and extending left, I blend in tone 4 with the tones already there. This brings out the point in the lip while placing the mouth's entire left side in shadow.

The cleft in the upper lip under the nose needs to be clarified. I place a combination of tones 1 and 2 directly inside this cleft in its shadowed right side. On the left side of this cleft, I place a combination of white and tone 1. The cleft itself forms a shadow directly to its left, and I indicate this with tone 3.

I brush in tone 3 on the mouth's left side for the shadowed area. Finally, I place a dark shadow with tones 3 and 4 under the lower lip which I'll use later for blending.

The Mouth: Step 4. In this final step I not only blend everything but also try to achieve a high degree of softness. The mouth should be as soft as any feature in the face.

Of course, the dark line denoting the lip separation must be there, but not prominently. This takes practice, so don't lose patience and proceed cautiously.

The final rendering of the corner of the mouth can be slightly darker than the other tones, but again remember to avoid harshness.

Even though the light source is from the sitter's right, the right side of the upper lip becomes vaguely darker as it nears the corner of the mouth. I work this in very gently.

As the mouth rounds off on the left side, it goes into deep shadow. I let the mouth fade into this shadow. This is a wonderful technique for achieving softness. While working with the shadow areas, be aware of the smaller shadow areas within the larger overall one. The depth and variation of darkness in the shadow area add a great deal to the creation of form.

As my final step I use white to denote the highlight areas. Especially prominent is the highlight on the lower lip which also gives a feeling of wetness.

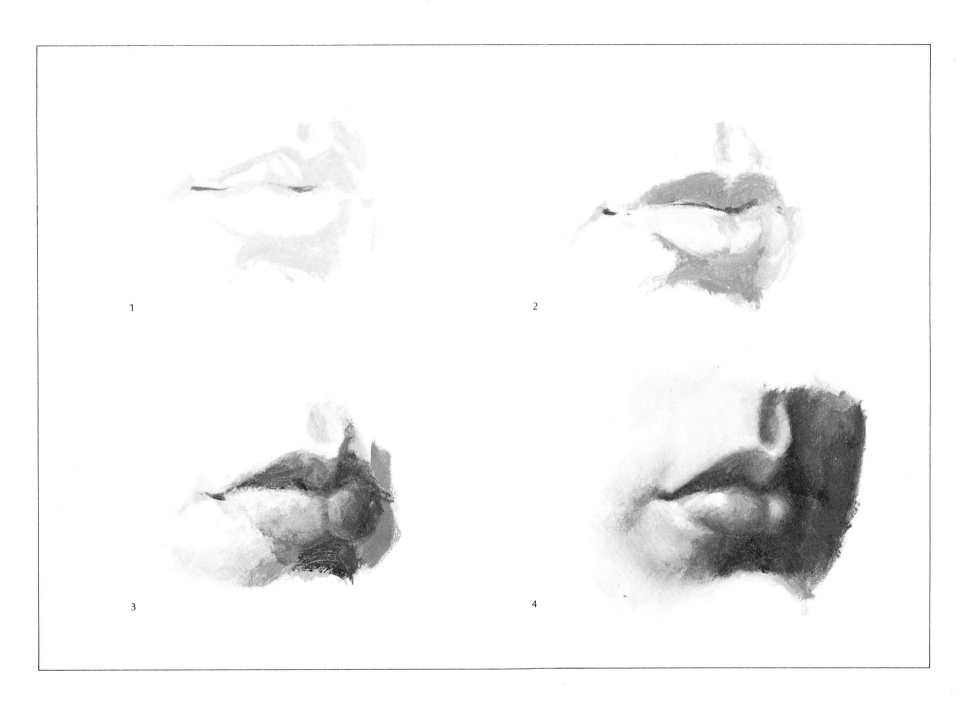

1

2

3

4

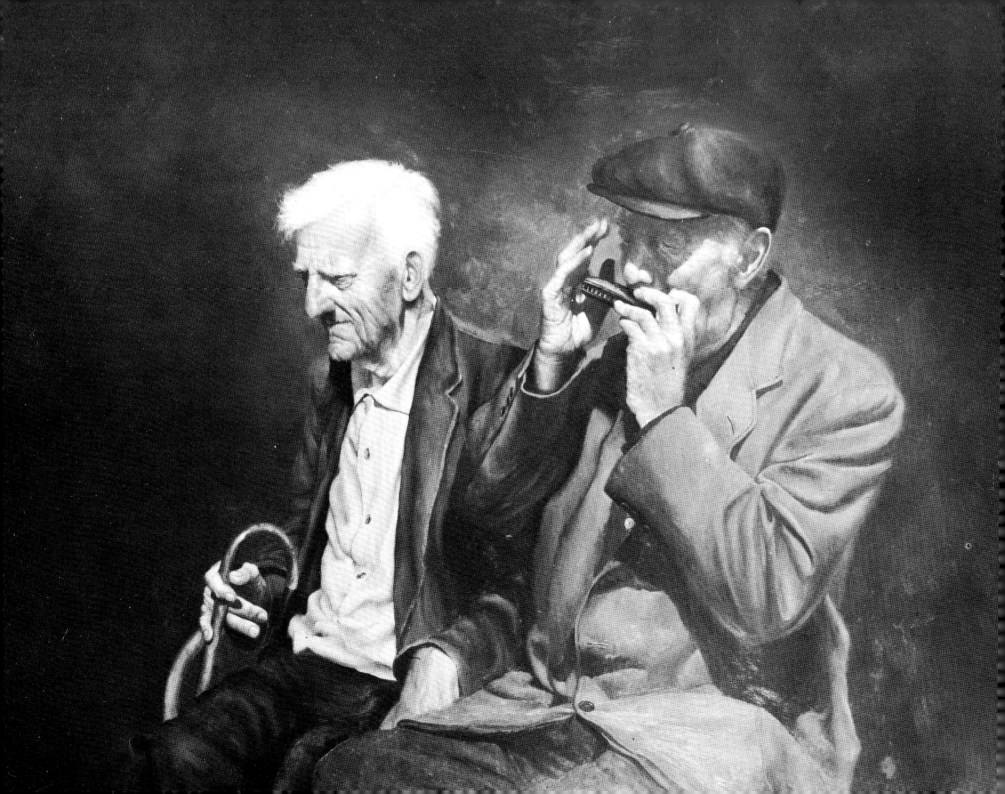

DEMONSTRATION 5: **THE EAR**

Senior Citizens, oil on Masonite, 31" x 48". Collection Mr. and Mrs. Robert Genin. This, my first painting of John playing his harmonica, and the second, page 26, were painted just a little over a year apart. In both I've carefully delineated the ears, making them an interesting part of the composition.

The beauty and the challenge of the ear is seldom noted or appreciated. Many fine artists work diligently to create magnificent features and skin tones, and then sluff off on the ear. Some strive to ignore it completely and arrange the ear so that it's hidden — maybe by a pose, or a hat, or hair.

The main reason for ignoring the ear is, in reality, a hesitancy to launch into painting one of the most challenging and difficult features. To have produced a well-painted ear is to have completed an exacting exercise on the use of tonal values which are blended precisely to create roundness, form, and depth.

Ears, indeed, come in a wide variety of sizes, shapes, and colors. Notice these characteristics in your sitter's ear before beginning to paint. The general skin tone of the head will be carried through onto the ear, since the ear is an extension or protrusion of the head. Establishing the ear's size is particularly important if your sitter is a woman. A female ear should appear more delicate than a male ear. If in reality it doesn't, then help it along. The particular ear in this demonstration is a man's.

If you love painting heads, then you'll truly enjoy creating a lovely ear. Certainly a fine ear isn't going to make a shabbily painted head come alive, but when the rest of the head is good, a good ear can only enhance and glorify what's there. It also tells the world that you were willing to attempt and achieve what others dared only to ignore.

The Ear: Step 1. No matter what the individual shape of your sitter's ear, it will follow a very general pattern — rather like a question mark. There's nothing definitive in this shape that I can describe readily in words. Besides the use of lines and letters to define areas, I'll use the following terms throughout. The shadowed center area next to the head which surrounds the opening to the inner ear is technically termed the concha, area A. The outer rim begins at the concha and extends upward, around, and part-way down the back edge of the ear, folding over in the process. I'll call this area the upper perimeter. The lobe is the bottom of this edge, following back up to the concha. The tonal values referred to throughout this demonstration are those referred to in the Materials and Methods section of this book.

The main purpose of this step is to block in the tonal values in their proper locations. I start by drawing in a sketchy outline with tone 1; I hit the light areas with a combination of white and tone 1. I combine tone 2 and tone 1 for the shadow areas and the lines found along the separate planes.

Remember that the ear is an integral part of the head. You must work to have the ear look as if it's growing out of the head and isn't merely pasted on. For this reason I lay in line B on the face side of the concha.

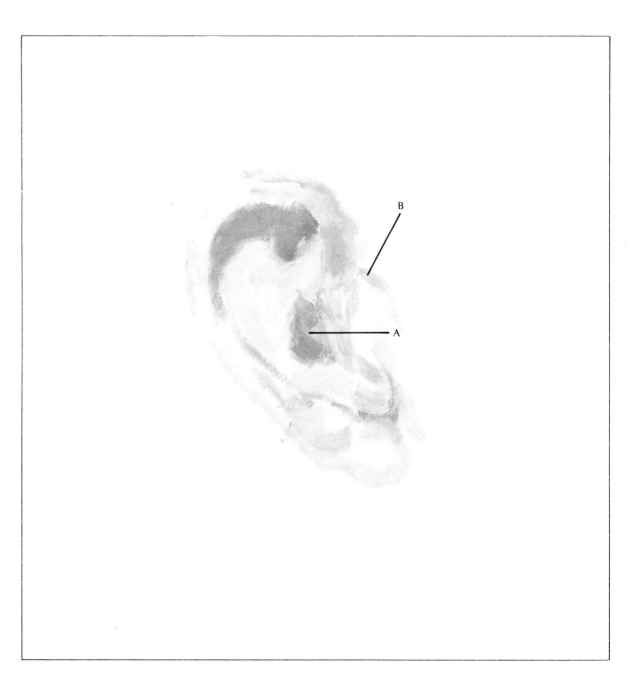

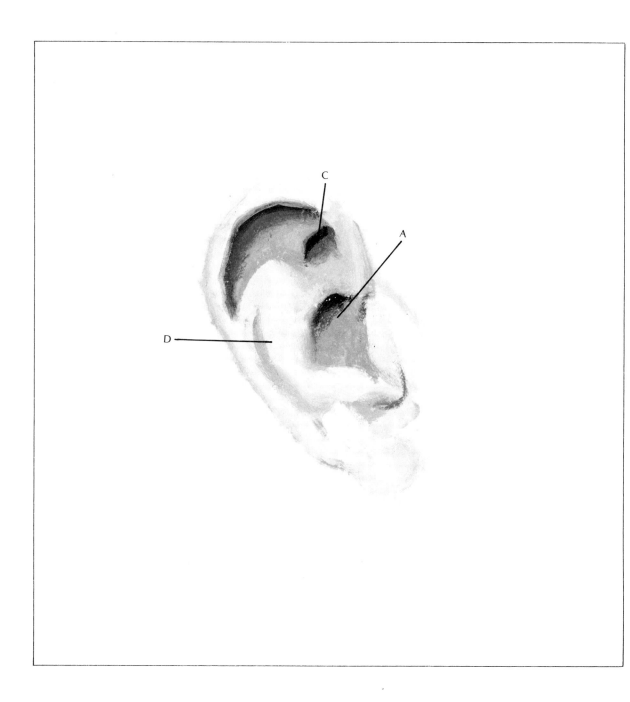

The Ear: Step 2. Now that I have a fairly accurate sketch of the ear, the next step is to lay in, side by side, all the prominent tonal values. I'm doing very little blending in this step, but by laying in the tones carefully next to each other, I set the groundwork for blending later on.

In area D, I lay in a combination of white and tone 1. I use this same combination on the lobe and also fill in all the other areas of light with it. Often these areas are very light due to the reflective nature of such firm tissue.

In this demonstration the light is coming very slightly from the subject's right but is mainly overhead. Therefore, shadows will fall downward, on a slight angle to the right. Because of this lighting situation, a very long cast shadow is formed under the folding tissue of the ear's upper perimeter. Keep in mind that this large prominent shadow is cast, not formed, so it won't be blended at the bottom. Form shadows are the only ones that are blended. To paint this shadow, I brush in tone 2 and also fill in the concha shadow, area A, with it.

Now, with tone 3, I sweep around the top of the two previously mentioned shadow areas. I fill in area C with tone 3 also. On top of these three areas that are painted with tone 3, I lay in a line of tone 4 for the deepest area of the shadows. Then I place a thin line of tone 3 above tone 4 in the top upper perimeter area only. As I stated earlier, all these tones are carefully painted next to each other and will be blended later.

I combine tones 1 and 2 and draw a line around the outer edge of the ear to create a feeling of form. However, while doing this, I'm careful not to make the shape too rounded or perfect. Ears are always irregular.

In the crevice where the lobe joins the head just below the concha, I lay in tone 3 and then lay tone 2 on top of it. Finally, over both tones I lay in a combination of tones 1 and 2.

The Ear: Step 3. Now I'm ready to start blending where I've previously been applying flat colors next to one another. As I blend, I add either small amounts of light or dark tones to achieve the precise tonal values I want. Until I start the actual blending process, it's impossible to predict the exact tone that will result.

The area between the outer perimeter and the concha, referred to as area D, is a rounded and irregular cartilage structure requiring much blending to capture its form. In order to paint a beautiful ear, it's essential to create beautiful roundness in this area. I blend my tones toward the peak of this area to begin achieving that roundness. The little shadows found in this area are all form shadows and, therefore, all require blending.

In the area where the upper perimeter comes up out of the concha, I drag my brush with white along the inner edge, just for a short distance. I place tone 2 next to the white, because this area goes very quickly into shadow.

I blend what I've laid down in area E. This particular cartilage always forms a bump of sorts, so it must be blended carefully to illustrate this.

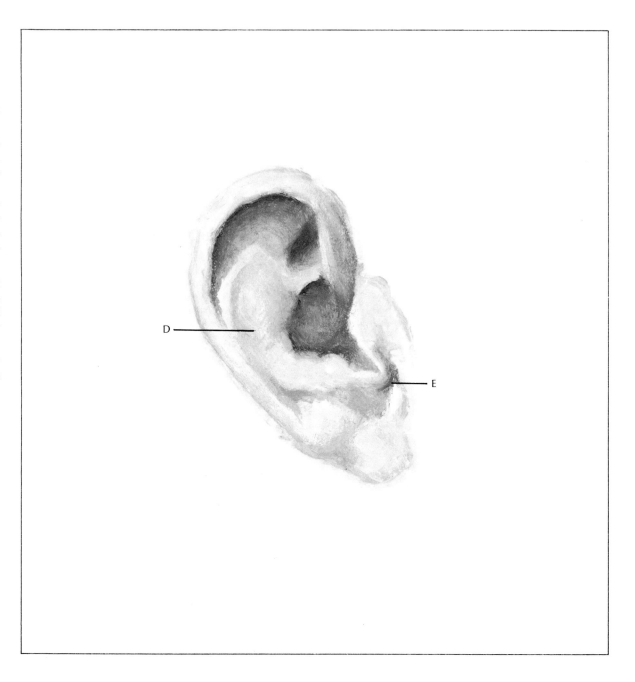

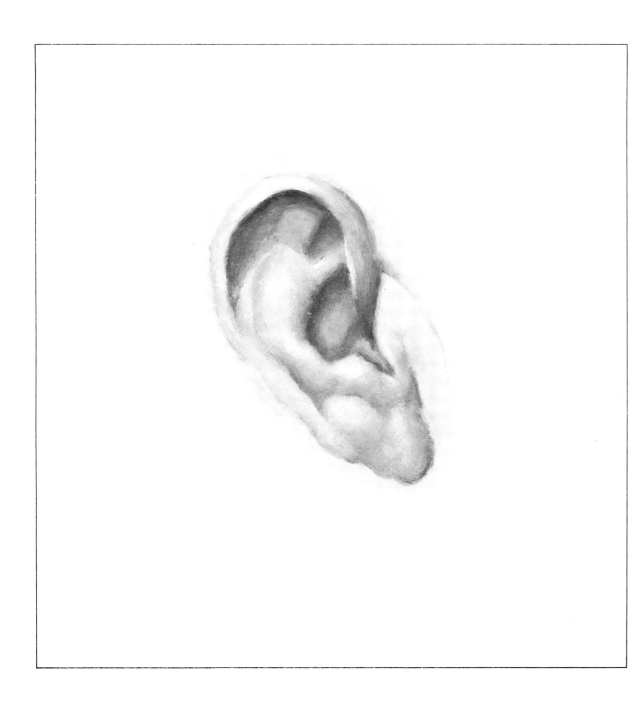

The Ear: Step 4. Some ear lobes are much bumpier and thicker than others, and this lobe happens to be one of those. Therefore, it's necessary to considerably blend the lights and darks to achieve the depth and form of this area.

A dark outline appears around the lobe as well as around the remainder of the outer perimeter, since the entire outer rim of the ear creates its own form shadow. Of course, I blend this line; its depth of tonal value varies, depending upon the tonal value adjacent to it. Therefore, this shadow line should be very light at the top of the rim where the light hits it directly.

Now I check all tonal values to make sure they're correct. I add light or dark tones where needed to correct any errors. You may even slightly exaggerate the lights and darks if you think this is advisable. As a final step, I use almost pure white on a soft brush to paint in my final highlights.

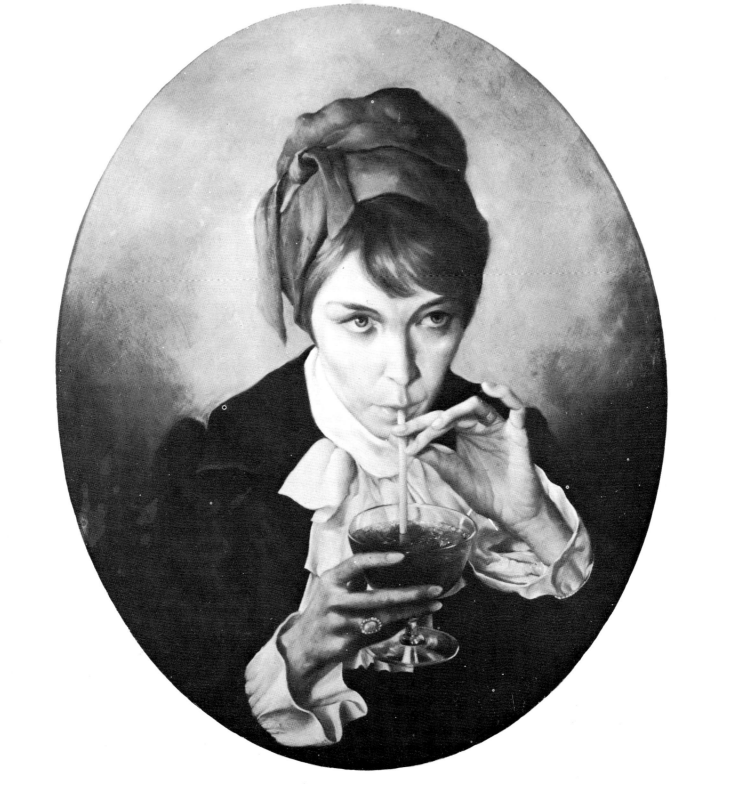

DEMONSTRATION 6: **THE FEMALE HAND**

Girl with Crème de Menthe, oil on Masonite, 25″ x 21″. Collection Mr. and Mrs. James Vaughan. This painting employes the use of one predominant shape — the oval. Not only is the painting placed in an oval, but the model's face, her left hand, the glass, her ring, and the cuffs of her dress all reiterate this shape.

A woman's hands can silently express much of her inner self. The manner in which she moves and places these beautiful tools can often convey the woman's momentary mood. Love, grace, charm, nervousness, or unrest are only a few of the emotions revealed by the hand's unspoken language. In the older woman, hands may show the strain of labors.

Even though the hands may be fascinating and expressive objects in themselves, don't be carried away by them. Remember they must advance you toward your goal of *painting the face.* The head and the hands must work together to convey the same mood you wish your sitter to portray. Be very aware of this when selecting your sitter. For example, you wouldn't want a delicate, lovely lady — one who possesses the very essence of femininity — holding her glass like a sailor.

I personally prefer very feminine and graceful subjects if I'm dealing with a young female sitter. Therefore, I'm more inclined to stress the very feminine and graceful hand. To me a hand which is slender, well groomed, and moves with elegance is simply sheer delight — a joy to paint.

I've often heard that the hand is more difficult to paint than the head. I won't go so far as to agree with that, but I would say they're equally as difficult to do *well.*

I've chosen this particular example of a woman's hand, because it illustrates all the qualities I admire in a truly beautiful female hand. The fingers are long and slender, the positioning graceful and natural, and it possesses an aura of elegance. The predominantly exposed area of this hand is its palm which I also find interesting, because you don't often have the opportunity to study this view. The palm need never be avoided if exposing it will give the ultimately desired results, as is the case in this demonstration. The painting from which this example is taken can be found on the opposite page.

The Female Hand: Step 1. This hand, as I previously mentioned, is a detail taken from a completed painting; it's a hand in motion. The object being held between the forefinger and the thumb has been deleted to avoid confusion in these steps. However, in reality, the sitter is holding a straw. This knowledge is important to you in order to properly visualize the delicate straining of this hand and the reason for its positioning.

I use tone 1 for the basic outline of the hand, the fingers, and the nails. I apply this tone thinly and drag it around in order to achieve a very rough sketch. This same tone is used to place the creases and shadows on the hand. There's a ring on this hand, and I place its location with tone 1 also.

My sole aim in this step is to put down the hand's outline in a very basic manner. In this way I try to capture the essence of its motion and character.

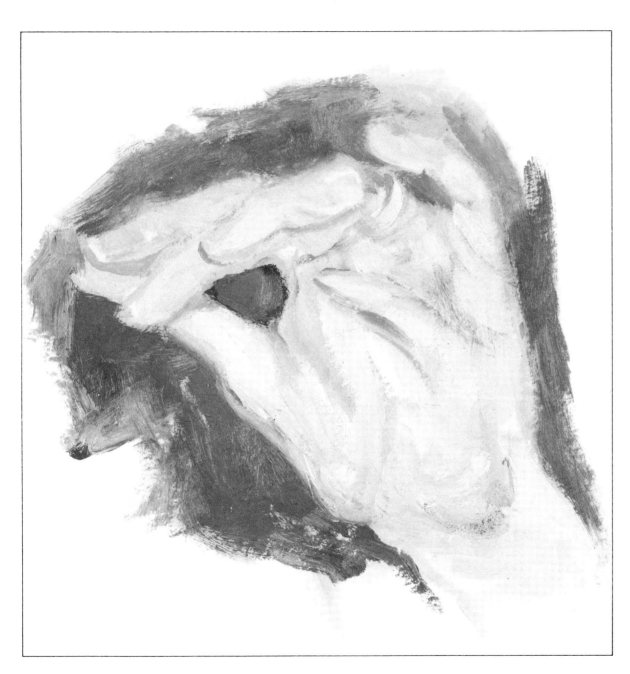

The Female Hand: Step 2. The first thing I do here is to hurriedly brush in tone 2 all around the exterior of the hand and wrist to create a background effect. This is necessary in order to have something into which I can blend later and create a feeling of softness around the outer edges.

Tones 0 and 1 are combined and used in varying degrees of light and dark to fill in all the skin areas. The changes in tonal value that I'm working to capture are quite subtle, but I lay in the values, one next to the other, without blending. I'm beginning to separate the lights and darks without being too precise about it.

I indicate the major creases and shadows with tone 2. Tone 2 is also used to outline the fingers where needed. I also use it for definition in any areas that need clarifying, because things tend to melt together and cause confusion during this step.

The ring receives a little attention now, and I fill in the lighter center section with tone 1. The edge of the ring is defined with tone 2. As you'll notice, the nails are ignored in this step. That's because they're a very detailed item; I must wait until later when the hand is in a more detailed state before I can place them.

Don't be discouraged if step 2 seems less pleasing than step 1. This occurs because the hand is so complex. Hurry through this step as best you can and don't try to straighten it out or define anything. This will come later.

The Female Hand: Step 3. The very basic groundwork has been laid in for this hand. Now I'll take what I've done and exaggerate or pull out every tone to its proper value. When I blend all these tones in the final step, I'll have a fine hand.

I accentuate the shadow in the palm of the hand with tone 1. I also place this tone under the entire length of the ring finger to indicate the shadow it's casting on the middle finger. I lay in the creases in the little finger with tone 2. This tone is also used to indicate the crease and the shadow formed as the thumb joins the palm. As the middle finger laps over the thumb, a dark shadow is formed. I lay this in with a combination of tones 2 and 3.

Using tone 1, I indicate the location of the cuticles and use a combination of tones 0 and 1 to hit the nail locations. The separation of the lights and darks, especially in the rounded areas such as the fingers and side of the hand, will give me the roundness, form, and depth absolutely necessary before I can proceed.

I hit the very light areas with tone 0. These areas are predominately the tops of the fingers, the high ridge of the fleshy pad along the side of the hand, the fleshy pad in the palm at the base of the thumb, and the area extending from that into the wrist. Earlier I placed the darks for shadows, but two areas now require slight blending to bring out their roundness. I drag tone 3 down the entire side of the hand and blend inward slightly toward the light area. I follow the same procedure for the outer edge of the thumb.

I lay in the deep and prominent creases with tone 3. The smaller creases will be laid in later. I darken the top of the ring with tones 3 and 4 as it rounds into shadow. As the ring turns down into the light, I use tones 1 and 2 to differentiate the areas. I place a thin line of tone 3 around the outer edge of the ring.

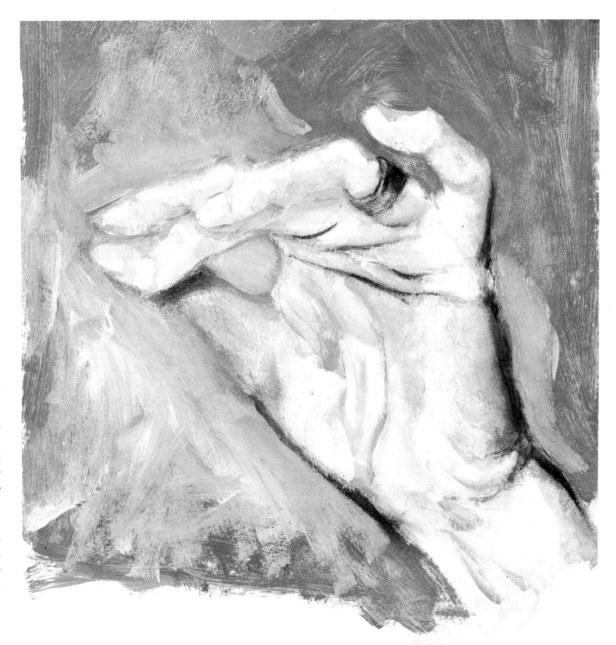

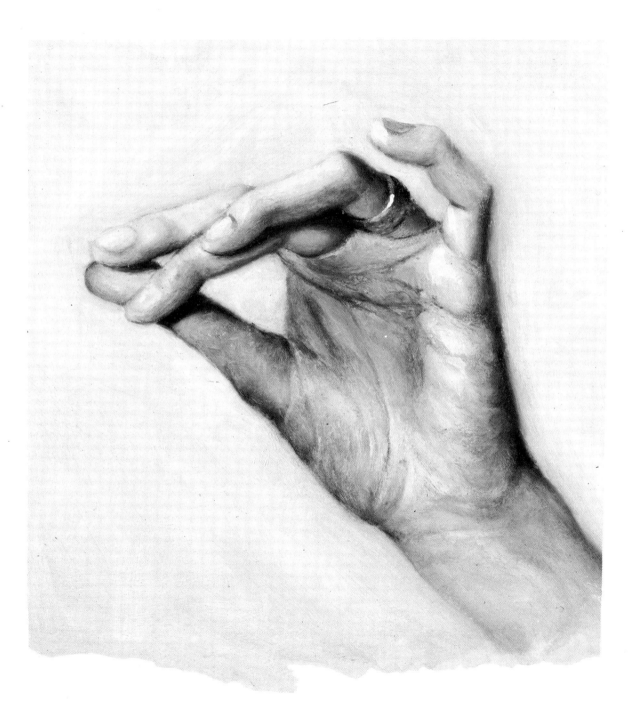

The Female Hand: Step 4. I'm now ready to begin the final process of blending. The tonal values may not be exactly what I want as I proceed, so I'm prepared to add darker or lighter tones.

I change the dark background to a light one for aesthetic reasons. It's done simply to contrast with the hand and has no technical bearing on the subject.

The process of blending lights and darks is a prime concern in order to properly construct all the form shadows which, in the final analysis, produce the contours and roundness of the hand.

Now I complete the nails. I work with the idea in mind that the nails don't just sit on the fingers; they grow out of the fingers and should appear to be tucked under the cuticles. A great deal of blending is required to achieve this. I use tone 2 to lay in the cuticle line and the outer edge of the nail. Tones 0 and 1 are used for the nails which are highlighted, excluding the nail on the little finger which is in shadow. Tones 1 and 2 can be used on this nail.

The ring is refined and completed with the use of blending. Tone 0 is used for the bright highlight that appears on it.

I add the wrinkles into the palm of the hand. Tone 2 is used to portray the depth of a minor wrinkle. If a wrinkle is deep enough to require special emphasis, I lay a thin, white line alongside it. The darker the wrinkle line and the more prominent the white line, the deeper the wrinkle will appear.

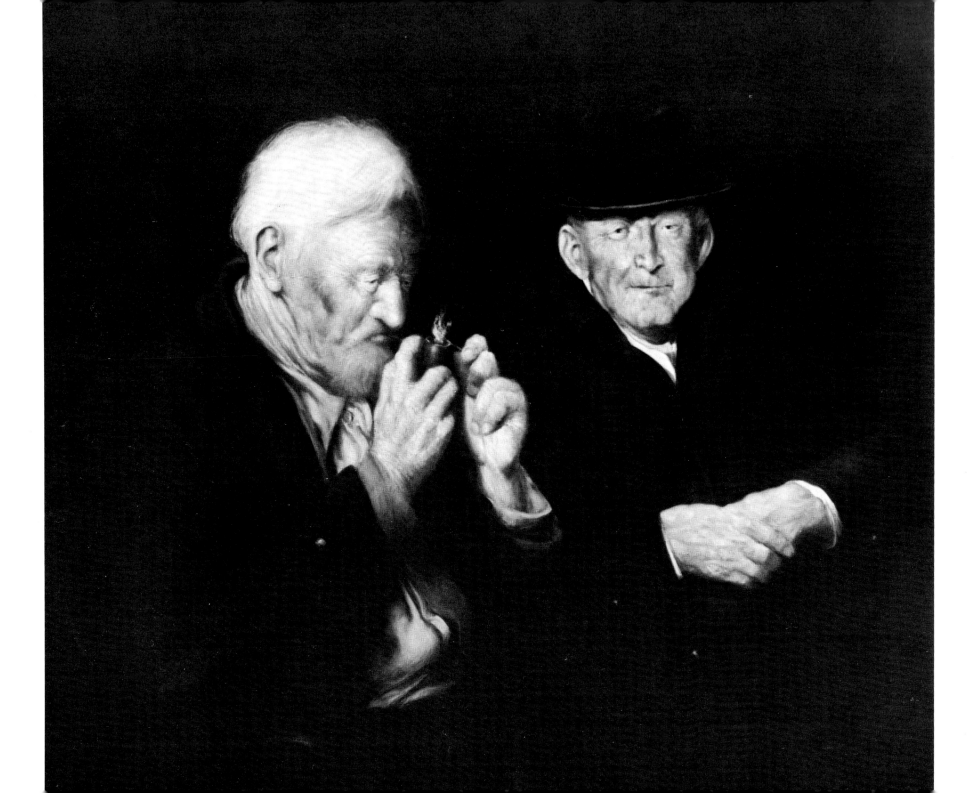

DEMONSTRATION 7: **THE OLDER WOMAN'S HANDS**

Lighting Up, oil on Masonite, 36″ x 38″. Collection of the artist. By placing these two old gentlemen at an angle to each other, I was able to have both a head-on as well as a side view. This positioning also allows the hands of both men to be in full view. Aging is especially noticeable in hands; the process of aging produces the same effects in the hands of both sexes.

I can't adequately explain why old hands are so interesting to paint — especially the hands of an older woman.

With age, the female hand will acquire a new and different type of beauty barring any large physical defects such as advanced arthritis, etc. You'll usually find *some* enlargement of the knuckles (be it arthritic or not) but this seems to be part of the charm of aging, if it's not too pronounced.

The skin texture of an old woman's hand is very interesting to paint. Quite often a transparent or translucent effect is evident on the top of the hands, the fingers, the wrist, etc.; this effect seems to enhance the softness of these areas, and allows the veins to show through. This seeming transparency is evidently the result of some sort of thinning process of the tissues.

This process further results in the many tiny skin creases that are noticeable in the hands of an older woman. I don't know whether or not there's any medical foundation for this. I've reached this conclusion purely from my own observations.

For these hands, I like to use a brushier technique than usual. Of course, it must coincide with the style I use on the woman's head.

Generally speaking, an old woman's hands, if rendered well, should portray the warmth, gentleness, and capable strength which she has extended to her loved ones and to the world throughout her many years.

The Older Woman's Hands: Step 1. Tone 1 is used exclusively for this beginning step. I want to establish the correct position of her hands as well as their proper proportion and tilt. I also brush in the shadows on the back of her hand very roughly just to maintain relationships. These shadows help me determine whether or not the drawing is accurate.

Capturing the correct tilt of her hands is, of course, very important. It sometimes means the difference between an appealing painting and one that's uninteresting. This demonstration is a good opportunity to practice without being concerned with the results if they're not perfect.

The Older Woman's Hands: Step 2. Here her hands have been clarified by the addition of shadows and light areas. Tone 1 is used strictly for outlining in this step. I use tone 2 for the shadows and indicate the very light areas with tones 0 and 1. I use these two tones to block in large, broad areas of tonal values with no subtle shadings added at all. At this time I strive to block in the strongest and most prominent tones which will give me the essence of my subject. The more subtle tonal variations will come later.

I'm careful to position in these large value areas fairly accurately, since they really provide the basic shape and form of the hands. From this basic form I'll build and expand in later steps.

I dab tone 1 very casually to give the impression of the crochet work these hands are engaged in.

The Older Woman's Hands: Step 3. Even though the hands are still very rough in this step, I've already developed a great deal of form and character. The rougher, more unblended technique that I use in this demonstration depends on the correct application of many values to be successful. Such a technique is in direct contrast to the careful blending I've used in other demonstrations. Thus, in this step the work still appears quite rough as I brush in the necessary tonal values. These values are forerunners to the finished applications of paint which I'll employ in step 4.

I need to add a background at this point, so I roughly brush in tone 3. Tone 3 is also used between her fingers where the background shows through them and also for the shadows that appear between the fingers on her left hand.

The same tone 3 is used for the other deep shadows such as those on the knuckle of her right hand, and the back and shadowed little finger of her left hand.

Tones 0 and 1 combined are used for the very light areas on her fingers and hands. Tones 1 and 2 are used as the in-between tones. I place these tones between the two extremes of tone 3 and the combination of tones 0 and 1, and produce the ultimate effect of roundness.

The crocheting is basically a stippled effect of tones 1 and 2 with tone 0 dabbed on the right side where the light hits. I loop the yarn over her hook and her finger with strokes of tone 0.

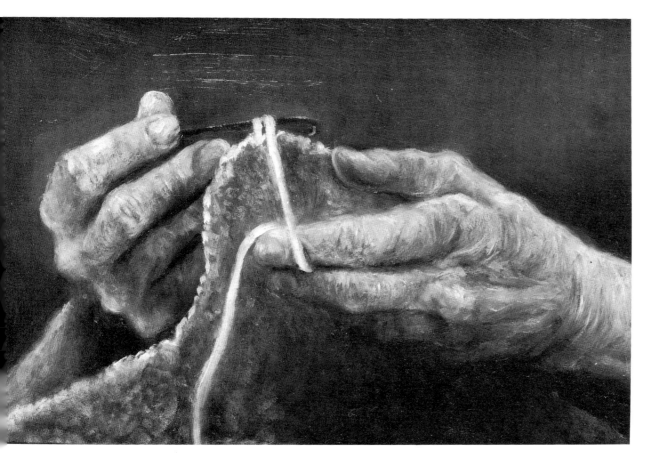

The Older Woman's Hands: Step 4. Before you become confused, I want to point out that for aesthetic reasons based upon my own preferences I've placed on her right hand the thumb which actually isn't visible. If you decide to do something like this, do it boldly and clearly or don't do it at all. Otherwise people won't be able to tell what's happening; confusion will occur and your efforts could ultimately be quite harmful.

Tone 4 is placed between her fingers. I use tone 4 on the back of her right hand and blend this particular area thoroughly. Her knuckles, just above this tone, are highlighted with tone 0 which is blended so that neither tone becomes too prominent, since they're recessed in the foreshortened angle of her right hand.

Tone 0 is also used for highlights on her fingers, but allowed to stand without blending since this area is in the foreground.

On her left hand I brush in tone 1 on the bottom of the thumb to represent the reflected light seen there. This tone is very carefully blended upward. Tone 4 is also brushed into the lower edge of her left arm and hand and blended lightly.

Many small creases are laid in by placing strokes of tone 3 alongside strokes of tone 0 and 1. Place these creases at your discretion rather than trying to portray them exactly as they appear.

For interest, I vary the background with tones 3 and 4. The background fades into almost total darkness at the left. I also allow her left arm to fade into the background.

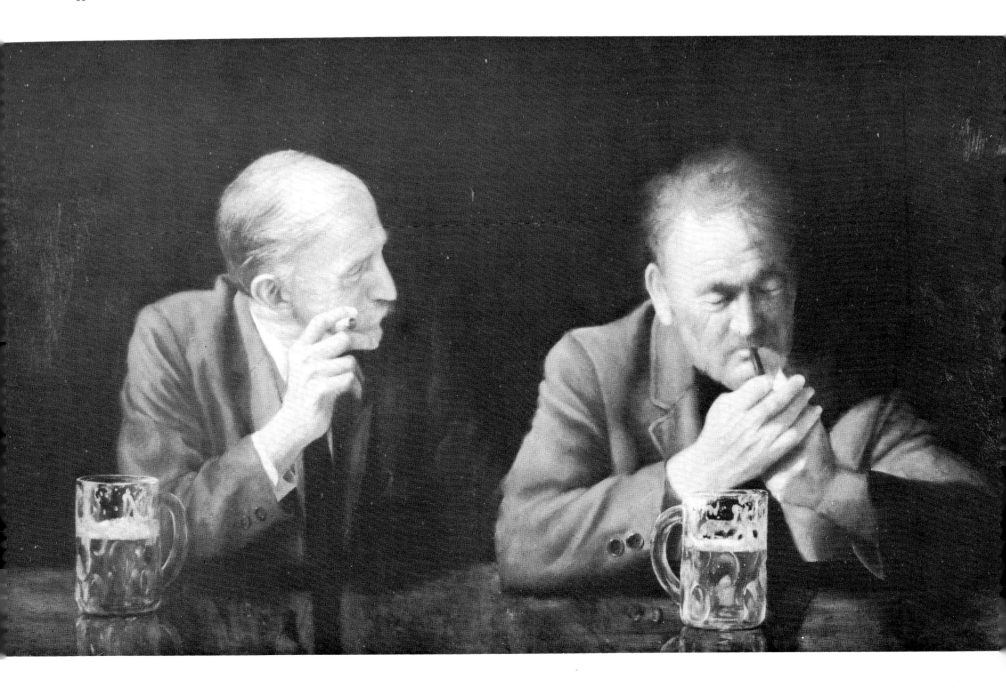

DEMONSTRATION 8: **THE MALE HAND**

Good Fellows, oil on board, 16" x 30". Collection Mr. and Mrs. Steven Atkins. These two men are obviously enjoying each other's company as well as their beers. While enhancing the mood of the painting, the beer mugs also serve to create a feeling of depth and third dimension. The hands of both men also add to the three-dimensional effect.

The male hand should portray its strength and masculinity. As a general rule, none of the delicacy of the female hand is apparent in the male hand. Even its manner of movement is different, and your attitude should differ correspondingly while painting it. Be bold when necessary and work with assurance.

The veins in a male hand are often predominant. The fingers are broad and the nails are blunt. The knuckles are large and pronounced, as are the joints where the fingers meet the hand. The skin texture also seems rougher than in the female hand. Together all these elements make the male hand recognizable as such.

The position of hands is very important. Whatever you choose to have them do, they should do it in a manly fashion.

Many actions can be done equally well by either a man or a woman, but each will use their hands differently. For instance, holding an animal can be done by either a man or a woman, so it's your task to position your male subject's hands so that their strength is conveyed, even though the action itself doesn't do so. You may become so concerned with positioning your subject's hands to show interesting lines or veins that you'll place them in a position that's awkward and doesn't reveal their character. If your sitter is doing something completely natural to him, or something strictly masculine, such as carving wood, you may have fewer worries.

Lastly, the hands and face should coincide in mood and action. They must work together as a unit to carry the mood. Don't be so carried away by certain aspects of extreme interest to you that you lose sight of the composition as a whole.

The Male Hand: Step 1. The hand I've selected for this demonstration is one at rest, but it displays all the masculinity I could hope for with or without props. When I've completed this hand, no one should question whether it's male or female.

I begin with thinned tone 1 for the outline and position of the hand and fingers. I indicate the knuckles lightly and rough in the location of the nails. In the back of the hand a few brushstrokes show indications of major veins and crevices.

Since my sitter is wearing a watch, I decide to include this and have painted its outline in its proper location on his wrist.

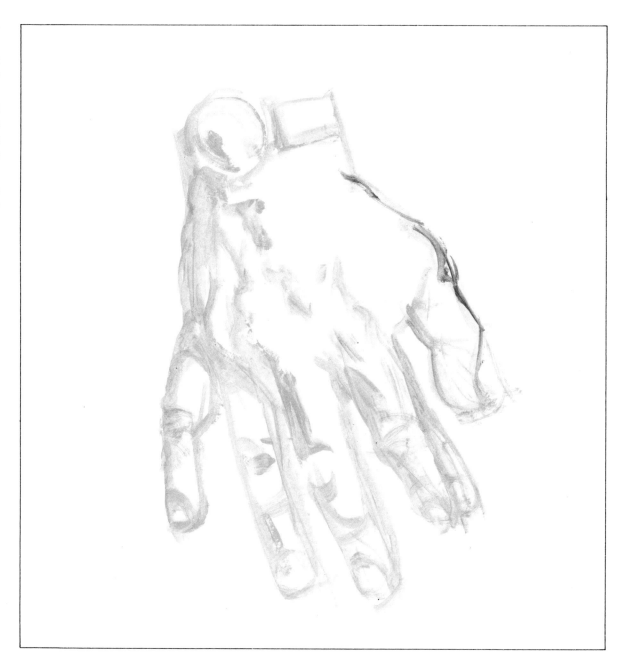

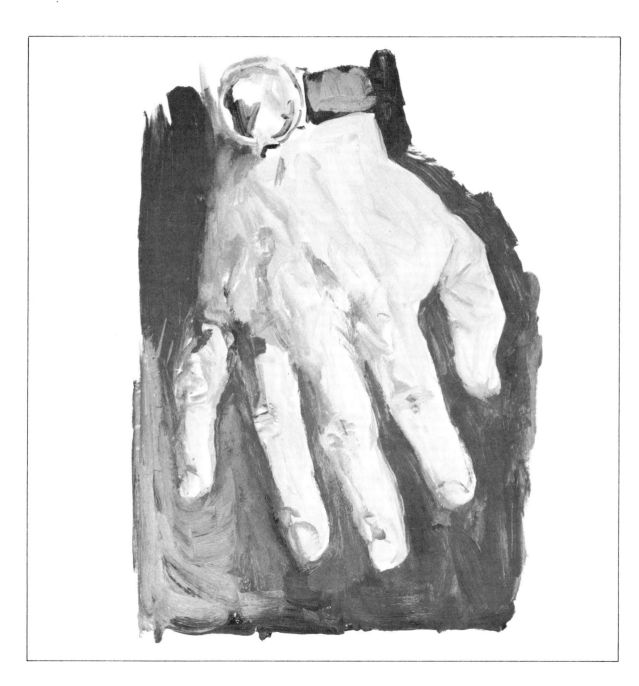

The Male Hand: Step 2. The basic tones which shape the hand are laid in during this step. These tones are blocked in now and will be blended later. Avoid blending at this point so you can judge whether or not the basic tones are accurate. I use tone 1 to render the basic skin tone. My other tonal values will be laid in on top of this tone.

The deep shadows on the ring finger and little finger are blocked in with a combination of tones 2 and 3. This same combination of tones I use to denote the fingernail outlines and an occasional deep, shadowy spot on the back of the hand.

This hand has the roughness often found in a male hand; it's characterized by bumps and mounds, other than veins, on the back of the hand. These will be illustrated by lights and darks laid side by side. I lay in the dark areas now with tone 2. I use this tone wherever I see these crevices to produce a nice mottled effect.

I use tone 2 in the knuckle creases of the fingers and in the thumb. I lay in tones 2 and 3 on the right side of the fingers to represent the form shadow there. The background is a combination of tones 2 and 3. I expand the rendering of the watch in the same way by representing very general areas of light and dark.

The Male Hand: Step 3. Much work with intermediate values is needed in this step to render the bumps and crevices in the hand. The high portions of these bumps and veins are depicted by blending tone 0 into the tone 1 that I've previously laid in. The shadows all appear on the hand's right side, so I lay in darker tones there. The darker the tone I use, the deeper the crevice; so I reserve my darkest tones for the deepest crevices and shade lightly for the minor bumps.

As I work these tones in, I may accidentally create a crevice or bump that isn't there. If the crevice looks good, I leave it there. This type of situation is called a *controlled accident* and can be of value under certain circumstances, if handled correctly. You may also find this happening in rendering a man's face, and again if it's appealing, leave it.

I render the shadows appearing at the tops of the little and ring fingers in a more accurate fashion with tone 2. I lay in tone 2 on the shadow side of the fingers and blend toward their tops for the beginning of the form shadows.

I define the knuckle crevices with tone 2 and use a combination of tones 0 and 1 for the highlighted peaks of skin. I depict the watch more precisely and expand the rendering to include the arm above the watch. For the shadow along the left side of the hand and arm I use tone 2.

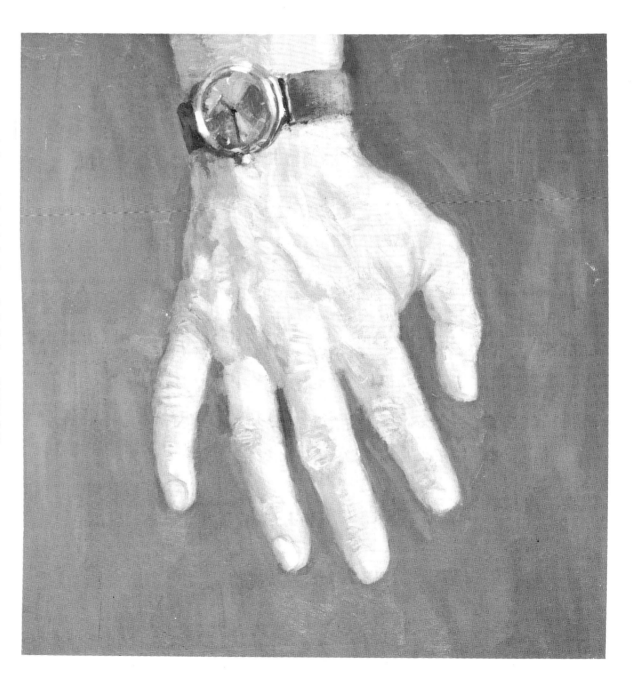

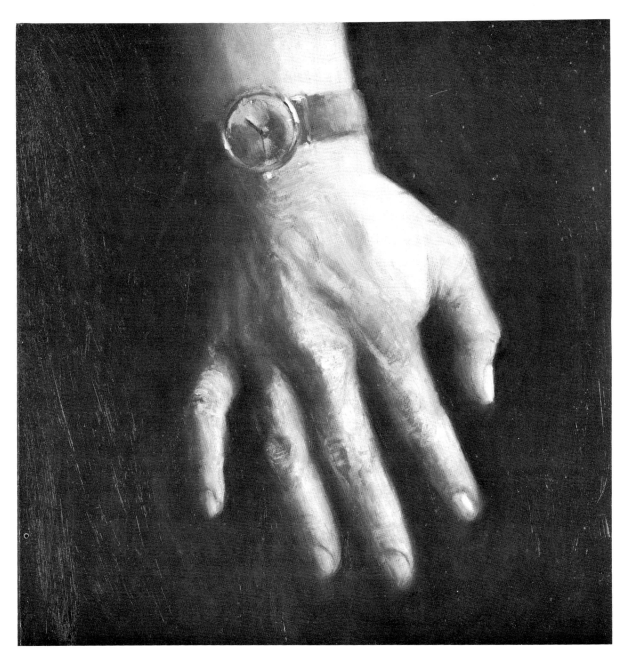

The Male Hand: Step 4. In step 3 the hand was nearly completed except for the contrasting deeper tones in the shadow areas which are necessary for contrast and depth. I've planned this demonstration to illustrate the quicker, "brushier" technique required to capture the roughness of a male hand as opposed to the smoother blending technique illustrated in the demonstration on the female hand.

The background is changed here to a combination of tones 3 and 4 for contrast purposes and also to facilitate blending, particularly around the fingers.

As you can see, form shadows appear on all the fingers and the thumb. For the darkest edge of these shadows I use the background tone, gradually blending this into the lighter areas. The creases in the knuckles are deepened by laying in tone 3 against tone 1.

The cuticles of the fingernails are defined with tone 3 but not outlined. They must be apparent but not harsh, so this tone is brushed in very loosely. The nails, likewise, are treated rather casually with highlights placed on the first nail and the thumbnail.

Since this hand is standing alone, I make two notable aesthetic changes that might not have seemed necessary in a total composition. I give a more pronounced crook to the little finger and to the thumb. In the little finger I add a few more creases, and in the thumb I cut down the width of the nail. This poetic license is permitted if the results are rendered well.

I deepen the shadows on the hand, noting especially the large shadow on the viewer's left. This is an abrupt form shadow — definitely not a cast shadow; the abruptness is caused by the ruggedness of the hand itself, and this form shadow is laid in with tone 3. For the final finishing touches on this hand, the watch and upper arm are given more contrast with darker tones.

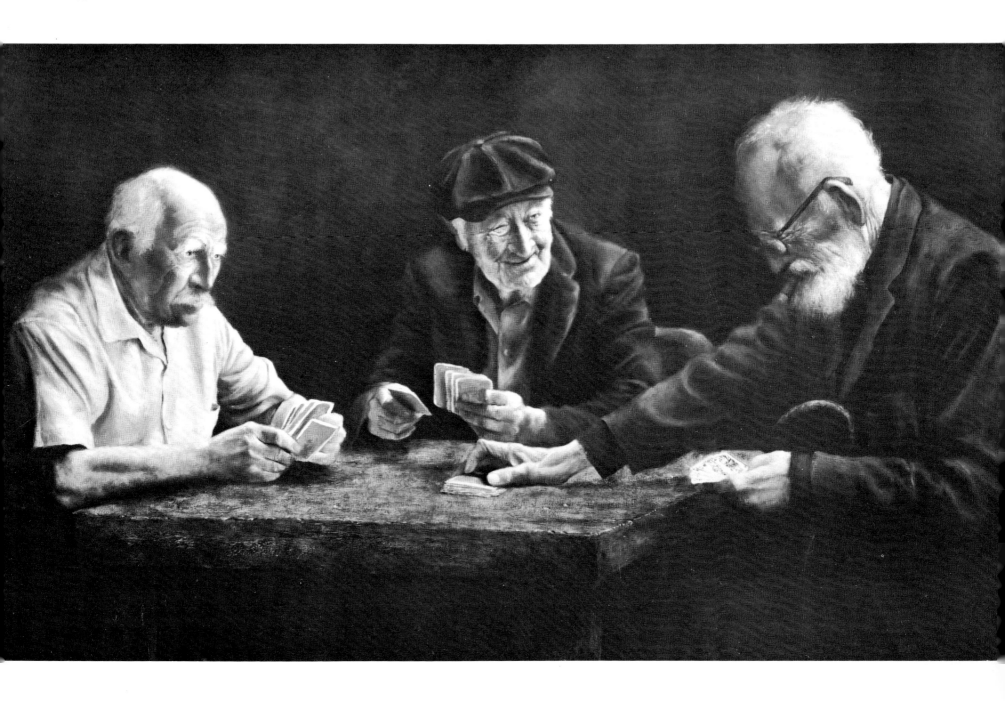

DEMONSTRATION 9: **HANDS IN MOTION**

Leisure Time, oil on Masonite, 20″ x 39″. Collection of Mr. and Mrs. Albert Martzloff. Enjoyment and anticipation are blended to create a feeling of camaraderie. Notice how the movements of the men's hands serve to reinforce these two emotions. The old man in the center is about to cast down the card he holds; the man on the right is reaching to choose from the deck. Both actions heighten the anticipation reflected in the characters' faces.

Hands in motion are a challenging problem; they're difficult to capture convincingly. Of course, the hands at rest also present difficulties, but in motion they must not only be well executed, but the actions they're performing must come across as well. They must really appear to be doing something.

Consider the subject I've chosen for this demonstration. His left hand has the least amount of strain evident since its function is solely to hold the apple. But strain is there and must be portrayed. The apple is being held against the pressure of being cut into, so immediately the action of that left hand becomes more complex than a simple holding action would indicate. His right hand is obviously exerting the pressure of cutting, so even more strain is evident there. In other words, these hands are working, producing stress and strain not seen in relaxed hands. This stress and strain must be conveyed to the viewer if the action is to become a beautiful and integral part of your painting.

Of course, there are an infinite variety of actions which can be performed by an infinite variety of subjects. Whatever action you may

choose, be sure that it's sympathetic with the rest of your composition. If the mood is restful, the action must be restful or soothing even though great stress is being exerted. In this demonstration, a great deal of strain is evident throughout, but it's centered around carving an apple which is a pleasurable pastime. Therefore, the stress doesn't detract from the peaceful atmosphere of the overall painting.

I've chosen an old man's hands in action in order to portray their gnarled features in strained and semi-strained positions. Old hands are particularly beautiful — often breathtaking when set in motion.

The painting from which this demonstration is taken is found on page 15. The left-handed action of the completed painting is transposed in this demonstration to right-handed, simply because most people are right-handed and this seemed more appropriate for demonstration purposes.

Hands in Motion: Step 1. With a 1/4" brush and tone 1, I delineate the action — the cutting and holding motions of the two hands. I concentrate on capturing the areas of the hands that express strain as well as the hands' basic outline.

As I discuss the procedure from now on, I'll refer to the left hand or right hand, meaning what would be the *sitter's* left or right hand.

I block in large prominent shadows with thinned tone 1. I use thinned tone 2 to come back over some areas to indicate their strength. Primarily I use it around the knuckles and define the fingers with it. I rub tone 2 into the tone 1 I've already laid in for the large shadow on the left hand. Tone 2 is also used for the form shadow appearing on the apple.

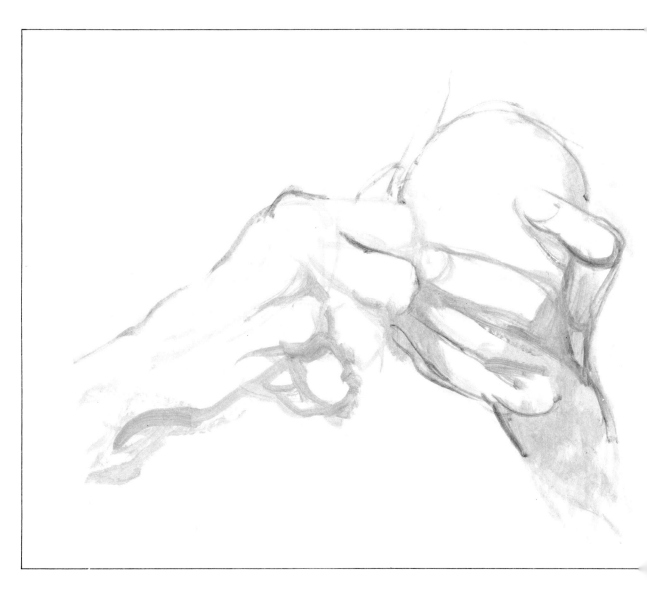

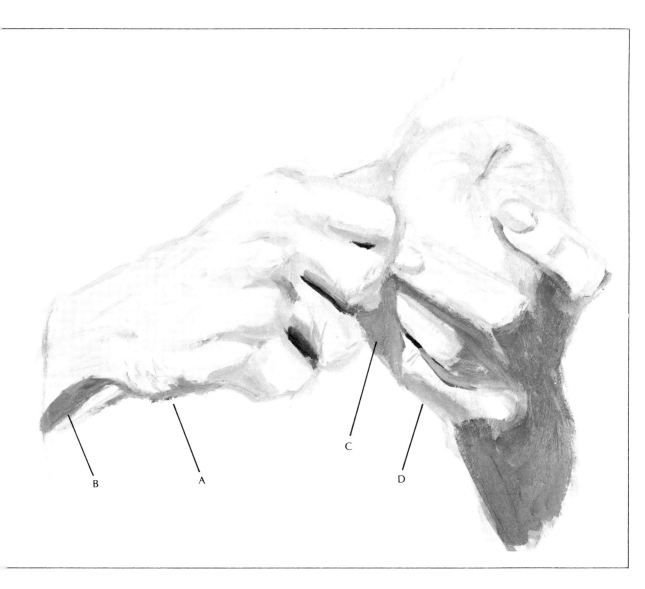

B

A

C

D

Hands in Motion: Step 2. In this step the main emphasis is on defining the drawing and denoting the separation of lights and darks. These tonal values will provide the essence of the hands.

First, I cover the light areas of the hands with a combination of tones 0 and 1 so they'll be in workable condition. Tone 2 is used to denote the lighter shadows such as those formed around the knuckles on the right hand and the form shadows alongside the fingers.

As you work in different areas remember to generalize. Don't try to be exact, but work to block in the various tones to provide a good foundation.

Area A needs both roundness and crevices which will be developed later. I lay in tone 3 for the dark edge of this area's form shadow, vaguely indicating crevices with tone 2. I use tone 3 for area B, an area clearly showing the strain of cutting and, therefore, very important. A dab of tone 3 around the knuckles helps give them roundness.

The deeper-toned cast shadows are depicted with tone 3. These include area C, the shadow between the third and fourth fingers on the left hand, and the large shadow on the back of the left hand. Form shadow D, being lighter in tone, is laid in with tone 2.

I use tone 4 for the very deepest shadows appearing between several fingers. In most cases, tone 4 is placed alongside tone 3 for future blending. The direction of your light source and consequent angle of shadows will dictate whether you should use tones 3 and 4 together.

I indicate the nails on the left hand with tone 2 for their cuticles and shadows. I give a bit of form and roundness to the apple and knife so they'll advance at the same pace as the hands.

Hands in Motion: Step 3. I use tone 4 to lay in a background for blending purposes and to provide contrast. I brush tone 1 into the light areas to simulate skin tone on both hands. Now, to avoid confusion I'll temporarily limit my discussion to the right hand.

I lay in the stress areas, such as area E, and knuckle definitions with tone 2. These should be soft, gentle tones, but brushing them in may produce more harshness than desired. When this happens, I use my finger to rub in the needed softness; brushstrokes can be added later. The tops of the knuckles — a highlighted area — are indicated with a combination of tones 0 and 1. However, don't use pure white here or elsewhere at this time. Pure white is reserved for later highlights.

To create the form shadow and give roundness to the fingers, I gradually blend upward into their light area, starting from tone 4 which was laid in-between the fingers in step 2. The wrinkles seen here and elsewhere are laid in with tone 3 with tone 1 placed alongside where needed to emphasize the crevices.

The roundness of the side of the hand is treated in the same manner as the fingers — that is, blending upward gradually from dark to light to create a form shadow. Then, I add the wrinkles. This ends my concentration on the right hand.

The entire triangular-shaped shadow area of C is painted in with a combination of tones 3 and 4. I use tone 4 on top of this to define the outline of the fingers. This area is a shadow cast by the right hand; no blending is required here except for a slight softness around the edges.

I refine the nail slightly using tones 1 and 2. The knuckle crevices on the left hand are tone 2 used lightly and not prominently. A combination of tones 0 and 1 is used alongside for emphasis. I slightly refine the large shadow in area F. I model the apple and knife in the same manner that I've used on the hands.

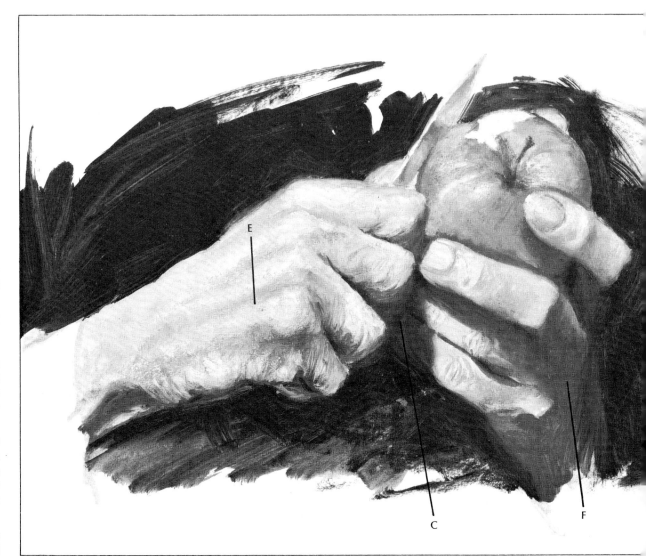

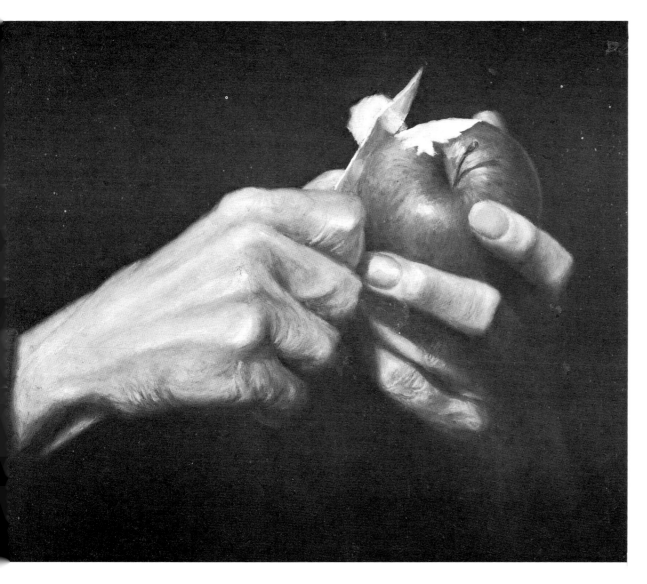

Hands in Motion: Step 4. Final refinement, blending, and softening take place here. Now it's time to add pure white highlights. The most prominent highlights appear on the knuckles of the right hand. I lay in white here and drag it back into the bones behind them, maintaining the brightest white on the knuckles. I drag the white in this manner elsewhere to give soft highlights as opposed to the harsh look of a dab of white paint. I add or delete wrinkles for effect as I see fit.

I've added the apple peel which extends behind the knife. This is purely an aesthetic touch; a decision such as this is clearly one of personal preference.

I keep finding things that need to be lightened or darkened. I keep modeling and refining until the hands emerge to my satisfaction.

DEMONSTRATION 10: **DARK HAIR**

At Rest, oil on Masonite, 34″ x 24″. Collection Mr. and Mrs. Martin Claire. Here the sitter's costume — a dancer's leotard — immediately suggests something of her personality, and certainly sets the mood of the painting. Her black leotard also serves to set off her skin tones and picks up the dark color of her hair.

Hair is an obviously unique part of the head. You should carefully study and consider hair before beginning to render it.

To begin with, texture will become an important element by itself. Ask yourself if your sitter's hair is coarse, wiry, fine, or limp. What kind of texture does it have? What's its style? How does the hair relate to the general shape of the head? Is it thick or thin? The answers to questions such as these will give you some idea of what you're trying to portray. Also they'll help you determine whether you're progressing in the right direction as you work.

Color, of course, is tremendously important and a somewhat more complex problem than it would appear to be. *Hair is not composed of one color.* If I made that statement ten times over, I couldn't emphasize it enough. Unless you represent all the various tones and shades present, no matter what you do, hair will *never* look like hair.

In this dernonstration, I deal specifically with dark hair. The variations of color won't be as apparent with dark hair as they are in the lighter hair colors, but they're still present and must not be ignored. The highlights in the hair will be a great deal lighter than the darker

portions, but don't compromise and shy away; that extreme contrast is part of the essence of dark hair. Also, when you're working in color, notice carefully that the highlighted areas of dark hair may not necessarily be just lighter shades of the overall color. You may find red, or blonde, or even gray popping out in these areas, so watch for these colors.

For this demonstration I've chosen a girl with an extremely plain hairdo. Her hair lies flat against her head and pulled back from her forehead. Studying this hairdo will answer most questions you might have on how to paint hair on a man as well.

In this and the demonstration immediately following, I concentrate on the difference between light hair and dark hair. Speaking of hair, I'd like to mention briefly the absence of hair, or near absence, often encountered in men. The same soft technique that's used anywhere that hair and skin meet is used in the areas involving hair and exposed scalp. Be especially conscientious about blending the edges of hair and skin tone to maintain softness. This particular hair problem — baldness — can look natural if carefully approached and handled, which is your goal no matter what the situation.

Dark Hair: Step 1. I lightly sketch the outline of her hair and the side of her face and neck with tone 1. It's necessary to include her face and neck in order to have something to blend her hair into to give her hair perspective and form. If I do her hair as a separate entity, it will be confusing.

I fill in her hair with thinned tone 1 and tone 2. I work to show the proper location of her hairline and any major placement of her hair, which in this case is its flow around and behind her ear.

With tone 3 I lay in her hair's part. The part is initially laid in with a dark tone for the sole purpose of depicting its location. The first rendering of her hair is much lighter than her hair really is. Its tonal depth will build up as my work advances. That's why the part must appear so dark, in order to show up.

I use tone 0 and tone 1 to paint in her entire face and ear. Tone 1 is used to indicate shadow areas such as her chin, her ear, and the left side of her face. Later, a little more defining will be done on her face for aesthetic reasons, but this is all that's needed right now. The entire rendering is surrounded with white, again for the purpose of future blending.

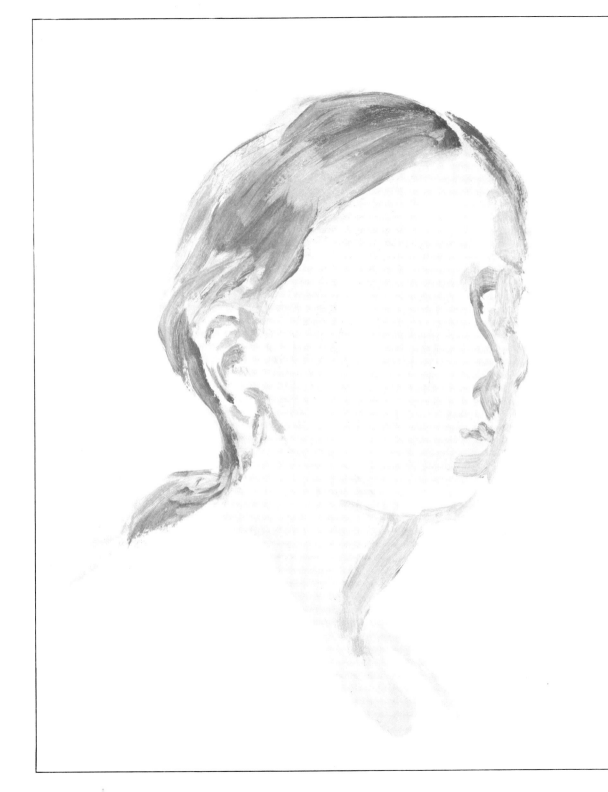

Dark Hair: Step 2. In step 1 I've shown the general location of important hair segments. The next concern is the separation of lights and darks on her hair.

As her hair extends down the side of her head from the part to her ear, a very soft wave is evident; a large highlight shines across the center of it. I indicate this highlight with tone 1 and use tone 2 for the darker areas above and below it. I continue to use both tone 1 and tone 2 for the lights and darks present elsewhere. I work in this fashion to complete all her hair areas, including the hair which flows down her back.

Her hair has now taken on a tone dark enough so that the part can be changed to the light shade it really is. A combination of tones 0 and 1 has been used to simulate skin tone and now should be used to follow up into the part.

Her hair on the left side of the part is shadowed and there I use tone 2. Placing the mere indications of features and shadows helps me properly maintain the direction of the light. I use tone 2 and tone 3 to portray her features and model her ear.

Dark Hair: Step 3. In this step I'm conscious of the precise degree of dark and light which appears on her hair. I lay in tone 3 for the darkest darks and start blending slightly with this. Actually I'm brushing or stroking this tone more than blending it, because I don't want to hide too much of what's already there. The different tones are needed to create the essence of hair. I place white in the large highlighted area of the wave and blend it slightly.

I begin brushing her hair back and forth into the background for softness. If this particular step is overlooked, the essence of her hair will be lost. I refine and define the hairline.

Now's the time to add any wisps of hair which are present. In this case wisps fall from her hairline across her forehead. Also, there are many interesting wisps falling around her ear. I portray all of these with a small brush and tone 2.

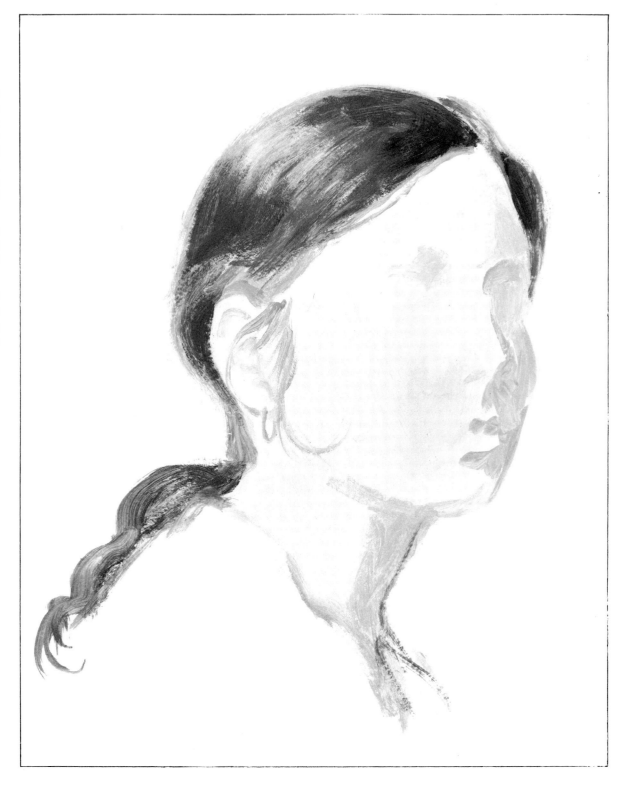

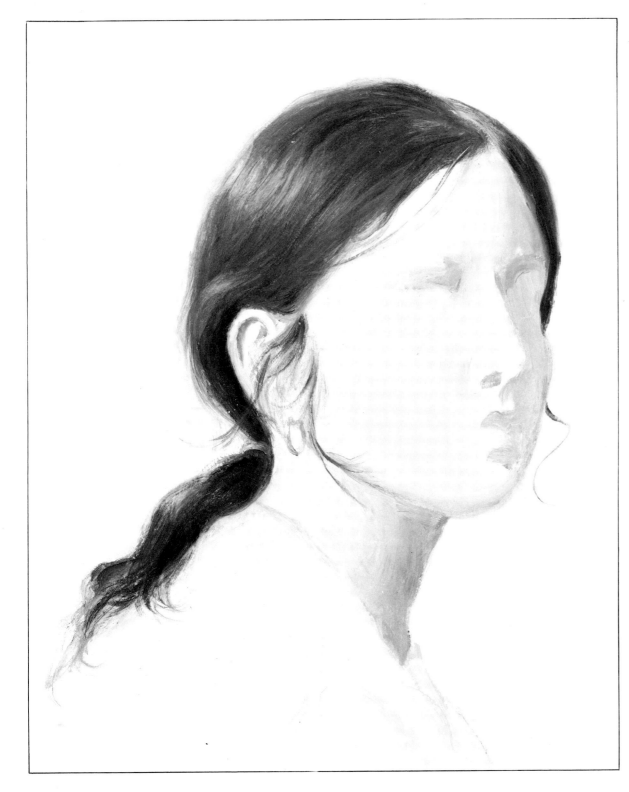

Dark Hair: Step 4. As opposed to other final steps in this book, I'm not just blending and refining what has already been laid in. I add more final tones and slightly blend these with the present color in order to create hair.

A small amount of white is brushed into the highlighted areas on either side of the part. Tone 4 is also placed in these two areas and dragged across the white. White and tone 4 will be dragged together throughout her hair where necessary to create tonal values and highlights. Therefore, white is blended into the wave highlight, but left brighter there than at any other point, since this is the predominant highlight.

I pay attention to my brushstroke as her hair flows behind her ear. My brush is important in depicting this sweep. The hair directly behind her ear is in shadow, and tone 3 is used there. Behind this, white is brushed in to denote the highlighted puff present.

I continue working her hair back and forth into the background. Notice that due to the nature of wisps, they'll have shadows. I lay these in very lightly with tone 2. Around her ear the wisps' shadows are there, but the wisps blend into them. I lay in the single wisp of hair appearing on the left side with one stroke of tone 3. Finally, at the nape of her neck a loop holds back her hair. I use tone 0 and tone 1 for it.

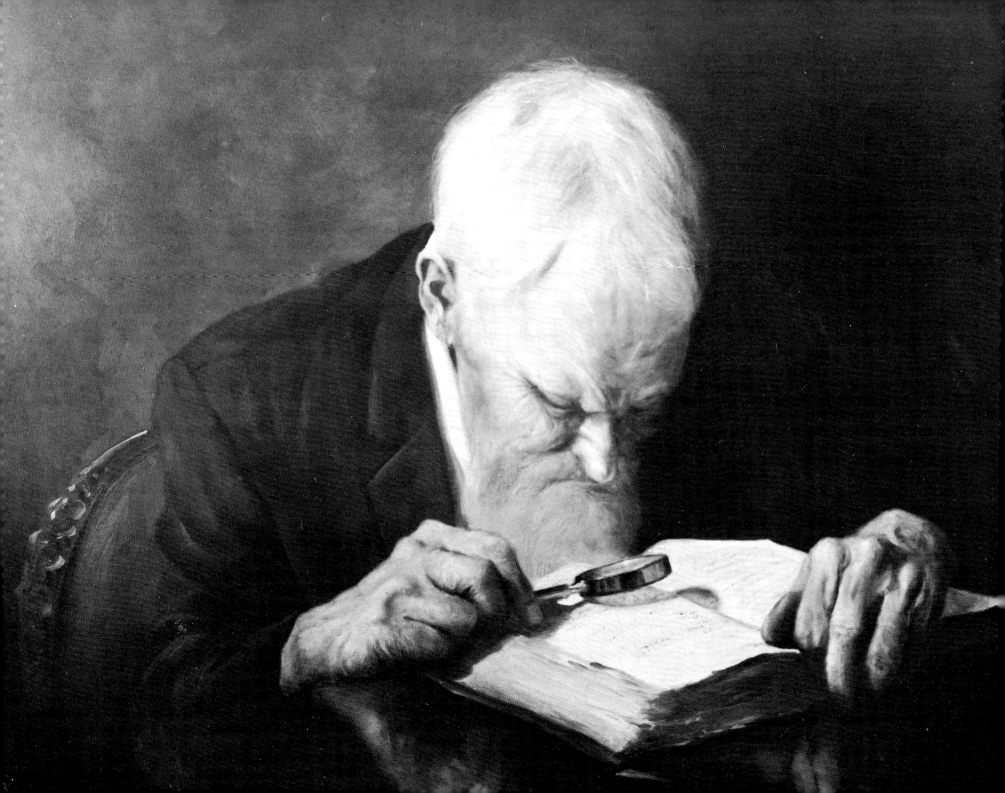

DEMONSTRATION 11: **LIGHT HAIR**

Search for Knowledge, oil on Masonite, 20″ x 28″. Collection Mr. and Mrs. Albert Johnson. The intensity of expression on this old man's face as well as his hunched-over position emphasize the feeling of concentration. Notice how his gray, almost white, hair is not merely a flat shade but a mixture of many tones.

Light hair involves all ranges of tones from the very blond up through medium brown. I certainly include predominately gray hair in this category, and probably most redheads would also be included, just for the purpose of technique.

With the light hair shades, every ounce of color is exposed, and there's no darkness available into which you can escape if the going gets rough. Lights and darks are both found here, of course, but the lights overshadow the darks in quantity; that's what makes the hair light, or blond. If you were to take a large segment of blond hair and examine it, you'd probably find very light (almost white) hairs, various medium tones, and possibly a few hairs that would be almost black.

As the light hits the hair, the predominant color of this conglomerate of tones will jump forward and become the highlight tone. You'll probably find a large contrast between that highlight tone and the overall color impression, but as you blend your colors in, they should appear natural and pleasing.

In the discussions on the number of shades which appear in a head of hair, I've been dealing exclusively with the natural hair colors. Dyed hair and most wigs present a different situation. Every strand is the same color! Therefore, the shadows and highlights are simply variations of the basic color; this presents the possibility of winding up with hair that looks painted on rather than real. To avoid this, I'd suggest you add a few variations of color, but do this with care, restraint, and discretion.

I've selected a very fluffy hairstyle for this demonstration in order to show the effect of light hitting such fluffy hair, the technique I use to handle bangs, as well as the simple enjoyment of working with an interesting hairdo.

Light Hair: Step 1. The subject matter for this demonstration includes the following basic characteristics: the subject's head is tilted; her hair is short and fluffy, and it surrounds her face. Capturing these basics is the job at hand in this first step. All the work in this step will be done exclusively with thinned tone 1.

I draw in the tilt of her head and neck. For your own visual aid you may want to include roughed-in features to help place her hair at the correct angle on her head. I work in short, curving strokes when laying in her hair to simulate its fluffy, flipped segments; they provide the basic ingredients of this hairdo.

Light Hair: Step 2. I keep building upon the base outline to achieve the *feel — not exactness —* in this hair's style. Exactness would tend toward harshness since my strokes would be too confined. Some leeway and freedom of movement are needed to create the hair's softness.

I block in her face, her neck, and her ear solidly with tone 1; later on I'll blend into these areas. I retain her right eyelash for the sake of relationships, since I'm working with bangs. I indicate her lash with tone 2. Tone 2 is used to indicate the shadow portion of her ear. Again, this is done to maintain relationships.

I now want to distinguish the very darkest and the very lightest portions of her hair. The darkest sections are indicated with strokes of tone 2, and the lightest sections with a combination of tones 0 and 1. Now I have a rough indication of the locations of major areas of light, medium, and dark tones around which I can build.

Light Hair: Step 3. Until now there wasn't any necessity for a background, but at this point it's needed for blending purposes. I lay in a rough background with a combination of tones 3 and 4. I choose these tones solely for contrast.

Now I start laying more tones into her hair. At this point I want to enhance and build on what's already there, and also completely fill in the blank spots that were left in step 2. The entire hair area will be filled in by the end of this step.

I continue working in the same manner as before with short, curving strokes. The side of the brush can be used for creating different effects. Also it's advantageous to use sweeps and flicks of the brush in various spots. This technique allows me to continue capturing the feel of her hair as I work.

I use tone 4 for the very darkest spots and tone 0 for the main highlights. I combine my other tones to create various shades in between as needed. I continue to brush, stroke, and flick in all these tones until I've satisfactorily captured the feel of her hair. I blend her hair back and forth into the background for softness.

Beware of one trap. The way I render hair isn't bound by precision of technique and accuracy. It's challenging, fun, and creative, but don't allow yourself to be carried away by your own design. Instead, you should be constantly guided by the subject before you.

Light Hair: Step 4. As in Demonstration 10, refining and defining are *not* the major objectives in this final step. Continuing to lay in tones on top of tones, modified by slight blending throughout, would be a more accurate description of the approach taken here.

You'll notice a deep crevice in the hairdo, almost a part, appearing in the center of her head. I use tone 4 for the center of this crevice blending upward into the lighter areas on either side. The other tones I'm mainly working with in the overall area are tone 0 and a combination of tones 3 and 4.

The necessary segments of color are already there, but now I have to capture the downy, soft fluff appearance of her hair. For this I suggest a sable brush. A small brush for individual hair and a sable fan brush in certain spots are also helpful.

I work softly and lightly with all tones. I refine and soften the highlights I've laid in. As her hair covers the facial tone, I'm especially careful to maintain a soft feathery touch, so it will fade off in such a manner. For the shadows found in these areas, I use a combination of tones 2 and 3. I use this sparingly and carefully since these shadows are very vague at best.

While blending her hair into the background, there may be areas that totally lose their identity. Leave these — don't define their outline; these "lost" areas enhance the hair's soft appearance.

I keep working softly and carefully until I've achieved satisfaction. The final rendering will have many contrasting tones. This particular woman is a dark blond, so there's more contrast than there would be in a lighter blond. Contrast is always present, but with lighter hair, it's less apparent.

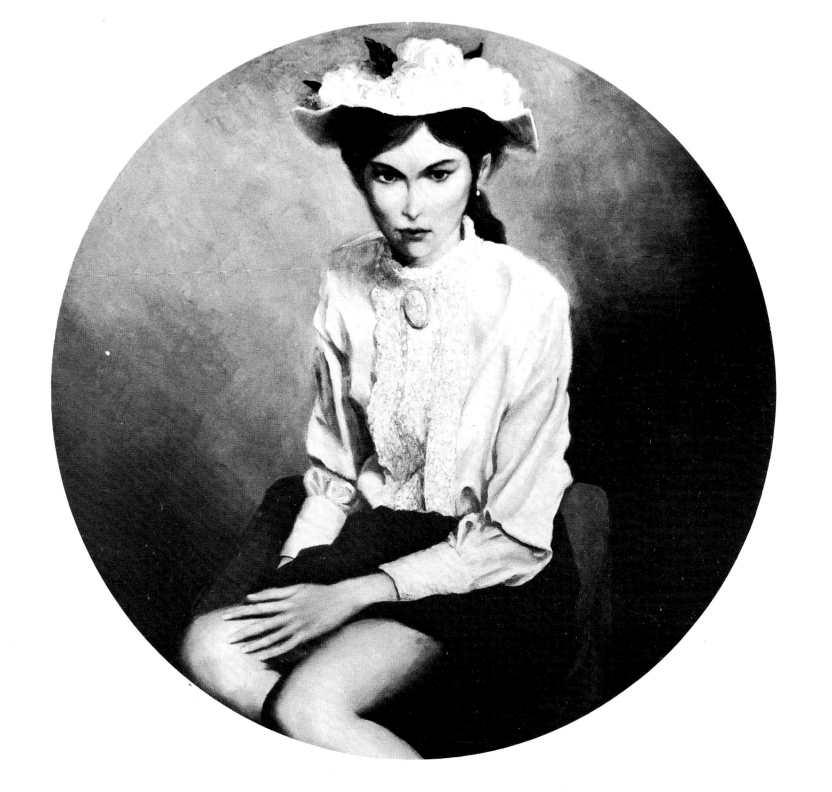

DEMONSTRATION 12: **THE FEMALE HEAD**

The White Flowered Hat, oil on Masonite, 14″ x 14″. Collection Mr. and Mrs. Morton Goldman. The pensive, enigmatic expression on the face of this subject creates an ambiguous mood; the viewer can read almost anything he wishes into this painting. What are the thoughts in which this young girl seems so lost? Notice how the variety of textures present in the old-fashioned lace blouse and flowery hat contrast with her smooth skin.

I've chosen a young woman to portray the aspects of a female face, because in youth the study of the face is uncomplicated by the process of aging. Therefore, the female head is viewed in its purest form.

When your subject is a woman, make an effort to find one that's attractive *to you*. In this way you'll be able to have empathy with and enthusiasm for your subject.

Remember that as an artist you have the freedom to alter whatever you see in order to create a more beautiful painting. That is, you can rearrange (with utmost care, of course) your sitter's features in order to better portray the character of the sitter as well as your own feelings about her. For example, I found the chin of the young woman used in this demonstration a bit too long. Shortening it by a small amount provided the touch that tied all her features together and enabled me to make the statement I was striving for in the painting.

A word of caution about altering the features: I paint character studies almost exclusively and hardly ever do a portrait *per se*. Therefore, I'm free to change my subject as I see fit; that freedom may be denied in a formal portrait.
Secondly, assuming you have this option to

alter features, do so with the utmost care. A woman's face is very delicate, and the slightest change incorrectly done can ruin the study. I find it a great advantage, therefore, to paint a monotone sketch of the woman and work any changes into it, so I'll know exactly what I want to do in the actual painting.

I also find that elongating a woman's neck provides a graceful touch. Again, I use great discretion and do this to a slight degree.

Faces of young women, although they don't have the character that years etch on them, which you might find in an older woman, sometimes reveal their personalities. Whether a girl appears to be sweet, sultry, frustrated, bewildered, or anything else, it's important to capture this and see that her clothes carry through the impression. For instance, a sweet demure little dress would only look ridiculous on a flaming siren.

The model I've used for this demonstration is the same model used in Demonstration 10. Consequently, the hair is the same in both demonstrations; I've deliberately refrained from rendering her hair precisely in each of the following steps, so that I can give more attention to her face.

The Female Head: Step 1. Besides the shape of her head and her features, the tilt of her head, any angling of her features caused by her head's tilt, and the relationship of her head to her body must be established in this step.

I work with thinned tone 1 throughout this step and pay attention to major shadows. The hair is of little importance right now, so I don't do any more than indicate where it comes across the forehead.

In order to get her features in their proper positions, you may find it helpful to lightly brush in some vertical and horizontal guidelines. This is perfectly acceptable if you find this helps maintain accuracy.

The Female Head: Step 2. In this step I proceed to apply paint in the broadest terms of light and dark. The simulated skin tone is tone 1.

For the dark shadows, her brow, and her pupils, I use tone 3. Tone 2 is used to block in the light shadows. Notice that the shadowed left side of her face is a form shadow. I lay in both light and dark tones here because tones are always darkest where the form rounds into full shadow. Tone 4 is used for the line separating her lips.

Her hair is blocked in in the same manner as her face, using tones 2, 3 and 4 to represent the lights and darks. I work to have all areas of my subject advance as a whole, as opposed to completing her face feature by feature.

The Female Head: Step 3. Everything gets roughly blended and refined in this step. I want to get a good solid groundwork laid in at this time, so that in my final step I can concentrate solely on my finishing touches.

The light source is quite plainly from the sitter's right to left, so consequently everything on the left side of her face is in shadow to some degree; even the white of her left eye is affected.

A form shadow appears on her forehead. This proceeds from light to dark as it rounds, but a burst of reflected light is seen at its far outer edge. This is light reflecting off some unknown object and is sometimes noticed at the edge of form shadows. I denote this reflected light by blending tone 0 all along the left edge of her forehead.

I darken and define her iris with tone 3 and then lighten it with tone 2. Tone 4 is used for her pupil and for the outer edge of her iris.

I lay tone 3 under the mucous membrane of her right eye for the shadow there. White is blended by the corner of her right eye up onto her nose. On the *left* side of her nose this same area is in deep shadow and I use a combination of tones 3 and 4 to portray it. The combination of tones 3 and 4 is also used around the upper edge of the socket of her left eye, being noticeably lighter in the center area. A highlight of tone 1 is placed on her left eyelid.

Tones 3 and 4 go into her nostrils. The shadow around the side of her nose, as well as the crevice under it, is denoted with tone 3. Her upper lip is tone 3, while tone 1 is used for her lower lip with highlights of tone 0.

A line of tone 4 is placed on the far left side of her face and blended into the lighter area of the form shadow. I choose tone 2 for the background. I proceed with her hair as in Demonstration 10.

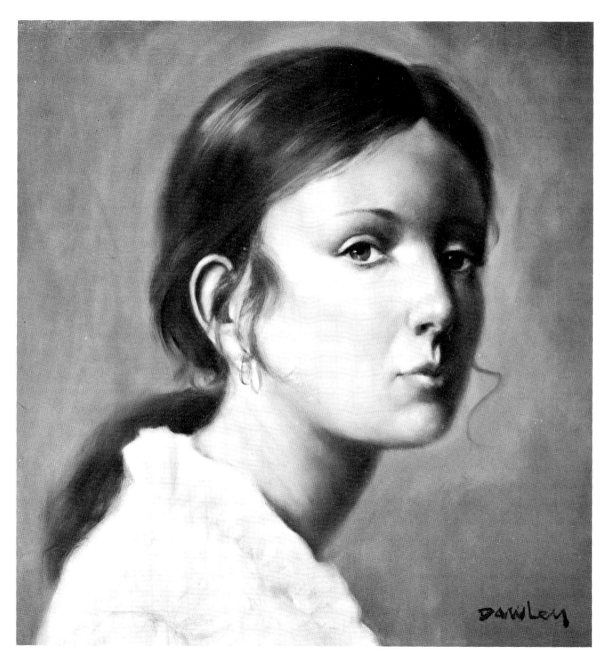

The Female Head: Step 4. As you can see, a great deal happens here. For the skin tone, I come in with all the variations of tones and blend them very carefully. I'm especially careful where the shadowed left side rounds into the light of the right side. You want this transition to be very soft with no harshness.

I indicate her right cheekbone with a highlight of white under which is laid tone 2. This area is blended very well so that her cheekbone is natural and noticeable without being pronounced.

The neck tones and creases are softened and blended well with the form shadow from the left side blended very softly into the lighter area. In this region I'm involved intimately with her jawline. The softness must carry not only around the form shadow but around her jawline as well. This is a specific delineation that must not be harsh in order to maintain the beauty of a well rendered head. This necessitates a high degree of fine blending. I define her eyes as described in Demonstration 1.

Her nose is completed as in Demonstration 3, her mouth, as in Demonstration 4, and her ear, as in Demonstration 5. I complete her hair as explained in Demonstration 10 with a few modifications as it fluffs around the right ear. I shorten the long wisp and give more fluff to her hair close to her ear. I feel this aesthetically enhances the final rendering, and this is my sole purpose in doing so. Also I've added wisps on the left side.

My model has taken on a rather delicate appearance which causes me to alter her clothing, changing it to the definitely feminine blouse I've laid in here. I feel this change is necessary to carry through the femininity portrayed by her face itself.

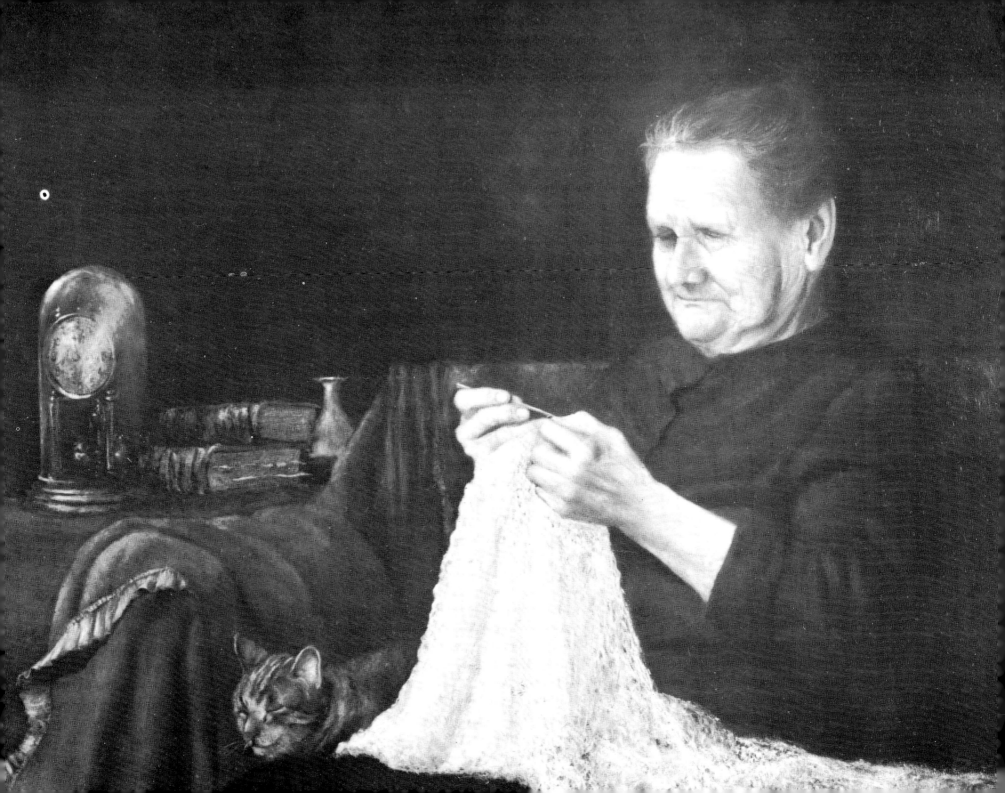

DEMONSTRATION 13: **THE OLDER WOMAN'S HEAD**

Passing Time, oil on Masonite, 15" x 21". Collection Mr. and Mrs. Melvin Alpren. The entire compositional structure reinforces the quiet, restful occupation of the elderly woman. The old books, the clock, and the dozing cat all combine to complete the design of the painting as well as enhance its mood.

When painting an older woman's face, you're challenged to discover and portray aspects other than aging physical features, which aren't very appealing in themselves. You must be concerned with more than just the careful rendering of wrinkles and bags under the eyes; you must try to discover what these physical characteristics indicate about the personality of your sitter.

The emotions which a woman has experienced throughout her life leave their visual stamp on her face. A woman's environment also plays a role in her appearance as she becomes older. The climate in which a woman has spent a majority of her life will have an indelible effect on the depth and quantity of wrinkles in her face. For instance, a woman who has spent a great deal of time outdoors on windy plains may exhibit more lines due to exposure than worldly experience.

Of course, these factors — emotions, climate, and general experience — have the same influence on the appearance of the older man. In short, with older sitters you must try to utilize physical idiosyncracies, and aging, to make statements about their character, thereby capturing their spirit as well as their appearance.

While the older woman may no longer possess physical loveliness or seductive charm, she has qualities that more than compensate for pretty features. The older woman embodies all our cherished ideals of motherhood; her beauty radiates from within. She's the warm, compassionate, self-sacrificing grandmother of everyone's childhood.

The Older Woman's Head: Step 1. Major outlines and angles are captured here with thinned tone 1. I lay in the position and outline of her head and place it on her body with an indication of the neckline of her dress. As you'll note, this subject has a very short neck, so her head seems to rest directly on her body, as is the case with many older people. The edge of an extremely prominent shadow is indicated in the neck area.

The barest outline of her features are brushed in to show their proper proportions and location. Deep shadows are indicated on her forehead, her cheek, and beside her right eye. Her hair is blocked in with tone 1, and the outline of the scarf on her head is laid around this.

The Older Woman's Head: Step 2. I need to fill in all areas with the broadest tonal values. No refinements of values take place at this point; I just block in values as I see them, and these will produce the fundamentals of an elderly woman's face.

Extremely strong light is cast from left to right on this subject, so that literally half of her face is in strong light, and the other half is in shadow. I use tone 2 to produce the shadowed right side of her face and neck. Tone 1 is used for the highlighted skin tone on the left side of her face and neck.

Tone 3 is used for both pupils. On the right side, it's also used for her eyebrow, shadows around her eye, and her eye's detail. On her left eye, tone 3 is used for her brow, but her other eye details are laid in with tone 2.

On the end of the right side of her nose, the shadow becomes deeper, and I brush tone 3 into tone 2 that's already there. Her nostrils are laid in with tone 3. For the moment her mouth is brushed in with tone 2; the line separating her lips and the corners of her mouth are indicated with tone 4.

The cheek shadows which appear on either side of her face are tone 3. Tones 3 and 4 are used for her dark hair, with tone 1 placed in spots where gray is prominent. I use tones 0, 1 and 2 to portray her scarf. A background is laid in with a combination of tones 3 and 4 for the purpose of later blending.

The Older Woman's Head: Step 3. To capture the soft wrinkles and pouches of skin on her forehead, her cheeks, and her chin, I add the intermediate tonal values. I blend these tones lightly, not too precisely, into the values already there. I constantly refer to the strong light source coming in from her left, because this will affect my work at all times.

Her eyebrows are very light and obscure; so I lay them in lightly with tone 2. For the pupils of her eyes, I use a combination of tones 3 and 4, and then use tone 3 for the iris. The wrinkles and other details of the eyes are brushed in with tones 3 and 4. I use tone 3 for the dark shadow on her right side between her eye and her nose. I blend this tone outward so it fades off and doesn't appear harsh.

I build the tonal values of her nose into one another to give form. I lay in tone 3 on the nose's right center area, maintaining the blending, but allowing this blending to halt rather abruptly at the nose's center line.

For the shadow formed by the full cheek on her face's left side, I use tone 3 and blend it well into the cheek. This will produce the fullness of that cheek. The crevice under her nose is laid in with a combination of tones 2 and 3. Tone 3 is used to depict her mouth more precisely, with tone 4 used to indicate the corners and dividing line between her lips. For her neck, I again lay in all the intermediate tones and blend to indicate the lines and loose skin found there.

I advance her hair and scarf accordingly and in the same manner by laying in all the values present. It's important that the various values all be laid in at this time to enable blending and refining in the final step.

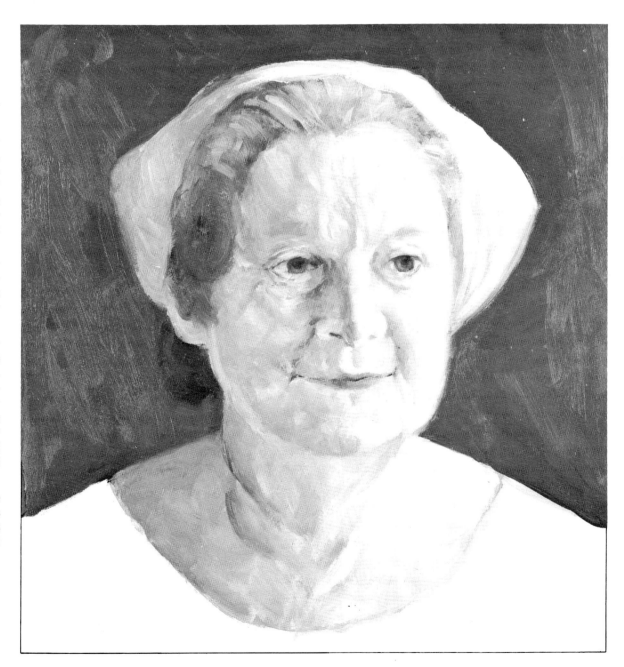

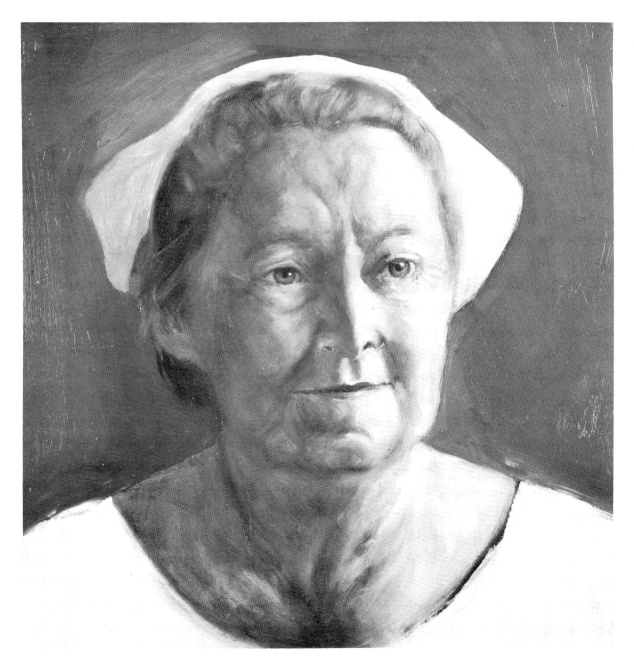

The Older Woman's Head: Step 4. All the shadow tones are deepened in this step while the light areas remain just about the same. As opposed to the high degree of blending and refining done to complete a young head, this head is left in a rougher, less defined state. An old face is by no means smooth, and by using a brushier or rougher approach you can capture its aged appearance. Therefore, as I lay in these final tones, I blend them as needed but avoid going overboard with such blending.

Generally speaking, the tone I use for the shadows in all areas is tone 3. Occasionally this tone is deepened where the shadows are particularly dark. The entire right side of her face and neck is in shadow, so tone 3 is used all over this area with other tonal values showing through to give form. The center of her right cheek rises up and catches the light, requiring tones 1 and 2 to be worked in there.

I deepen the crevices in her forehead and add several values here for emphasis, since this area is important to her character. Both eyes have highlights which can happen in this type of lighting. Even though the right eye is shadowed, it catches a flicker of light; this helps to add needed life, or sparkle, to the eye.

I add a center crevice in her lower neck for definition as it comes up from the collarbone. This is done simply with a stroke of tone 3; very little blending is necessary on either side. The lower edge of her chin is indicated with a thin line of tone 4 used very sparingly so as not to be either harsh or prominent. Her hair is a range of values — from tone 4 to tone 1 — blended somewhat but retaining a brushy quality to maintain the style of her face.

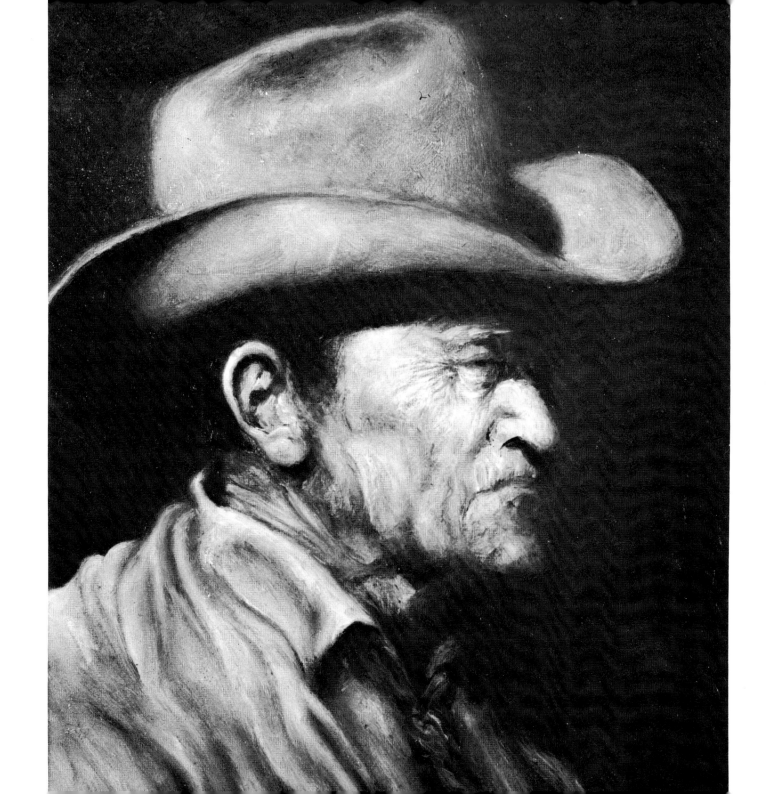

DEMONSTRATION 14: **THE MALE HEAD**

Cowboy Head Study, oil on Masonite, 8'' x 10''. Collection Dr. and Mrs. Arnold Kallen. Everything about this sitter was rough—from the expression of his face to the texture of his skin. In keeping with this "roughness", I painted him in a very rough way. As an extension of this feeling, I painted his clothing in a casual and un-refined manner.

One of the advantages of working with the male head rather than the female is that you're not hampered by the necessity of conveying beauty. Of course, even though you're not seeking prettiness, you must avoid ugliness. Quite frequently a man won't have what might be termed good looks but will have an interesting face. As a matter of fact, I find rugged faces great to work with; the strength and character they portray is, by and large, much more appealing than a man with bland good looks.

You may find a great head that you don't want to pass up but which has a prominent, un-appealing feature. Study the feature, and if it can be changed without major problems, go ahead. A man's head isn't delicate like a woman's. Whereas a slip of the brush can ruin a woman's appearance, there's a great deal more latitude available when working on a man's features. This gives you a good chance to alter some unappealing feature and achieve a more pleasing effect.

The head in this demonstration is nearly bald, and I thought it particularly interesting for this reason. Baldness isn't something you'll probably often work with, but on occasion it's interesting and needs to be handled well.

The Male Head: Step 1. My subject displays three conditions of particular interest. He's nearly bald with only a few wisps of hair noticeable on the top of his head. This will cause me to deal with the rounding of the scalp away from the forehead — an area which ordinarily would be concealed by the hair. Next, because of the angle of his head, his right ear is a slight protrusion appearing beyond the side of his face. Finally, the left side of his face is obscured in deep shadow which will eliminate a great deal of detail work in that area. However, this will make it necessary to do everything else perfectly, because these light areas will be the focal point. Also, I'd like to point out that since effort will be concentrated on the portrayal of the head, the clothing will receive little attention and be presented for the moment merely as a V-necked top.

Tone 1 is used exclusively in this step. First, I lay in the shape and tilt of his head. Then I indicate vaguely the location of his features. The very darkest shadows are laid in around his nose, his chin, his neck and left side of his face. I place his ears and indicate with a stroke the tuft of hair on the top of his head. The shape of his shirt is laid in completely with this tone.

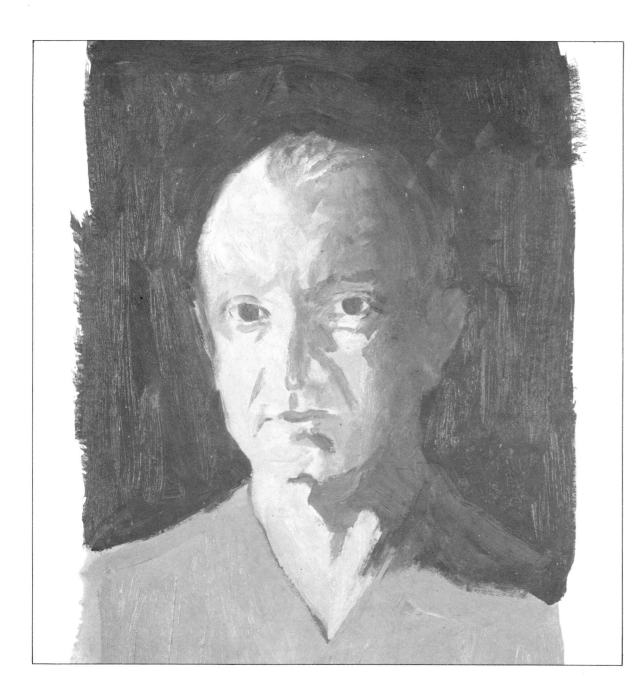

The Male Head: Step 2. I lay in the major tonal values in this step. I fill in all areas with these values to provide a basis for future refinements. I use tone 1 for his unshadowed skin.

The large shadow on the left side of his face I lay in thinly with tone 3. I recommend a thin use of this tone, since later it will be fading into near black. As this shadow rounds into the lighter portions of his face, I lighten the shadow so that it eventually can be blended together with the lighter tones.

The shadow on the facial area is a form shadow; they must always be blended to achieve roundness. On his neck, however, there's a cast shadow which isn't blended, except to eliminate its harsh outlines. Other shadows on his face are represented with tones 2 or 3 depending on their depth.

I use tone 3 for the pupils of his eyes and the creases in his upper lids. The upper lip of his mouth is in shadow and tone 3 is used there. Tone 3 is used for the line separating his lips and for the corner of his mouth on the right side.

His head becomes lighter at its top, so I blend tone 0 into tone 1 for this and then use tone 3 for the hair in that area. This man does have hair on the sides of his head leading into sideburns; I represent this hairline on his right side with tone 3. A stroke of tone 1 next to this represents his ear.

A combination of tones 1 and 2 is used for his shirt with a thin line of tone 4 for the shadow cast by the right side of the "V" as it stands away from his neck. I need a background for future blending and choose a combination of tones 3 and 4 for this.

The Male Head: Step 3. The deep shadow on his left side becomes darker than the background. I lay in tone 4 on the far left side and blend it gradually into the lighter area.

Tone 4 is dabbed in for the pupils and is also used to outline the lashes of his upper lids. The creases of his lids are blended slightly to create shadows rather than distinct creases.

His nose begins to acquire a three-dimensional effect by blending tone 3 gradually into his lighter left cheek. His nostrils are tone 4 with a dab of tone 2 next to it on the left side where the light hits their outer portion. A streak of tone 1 is laid along the length of his nose for this strongly lighted area.

The crevice under his nose is tone 2 with tone 1 laid next to it on the left. I use tone 4 for the line between his lips and in the corners of his mouth. For the facial areas, I lay in the various tonal values which are the subtleties that begin to give life to his head. I blend lightly but try to have all tonal values there for the final step. These values will produce the furrows in his brow, the shape in his chin, and the character around his eyes.

His eyebrows are placed with tone 3. One crevice, found on the edge of his right cheek by his nose, is most prominent and will be worked on more precisely. The shadow produced there is a form shadow, so a line of tone 4 is blended gradually up into his cheek.

With such a strong light source, there's room for many strong highlights, but don't be carried away. Three is the preferred number to prevent the eye from skipping around too much. I particularly highlight his lower lip, top of his nose, and his right cheekbone. Other lesser highlights may be used as long as they don't become prominent.

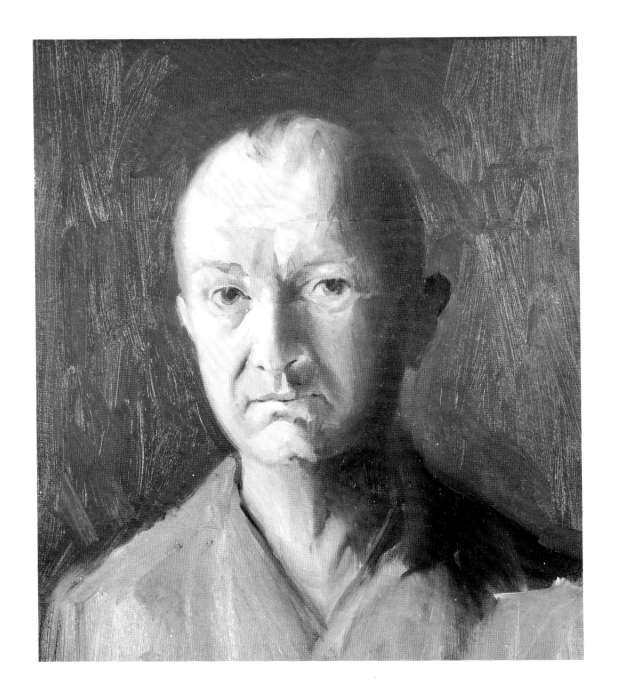

The Male Head: Step 4. Here I darken the shadow areas to produce form and depth. However, I don't blend them too completely; that way a certain ruggedness desirable in a male head is maintained. In this step I've added a few minor changes to my study. Basically, he remains the same, but I've given him bushy sideburns, a mustache, and a change of apparel to achieve his new appearance.

His eyes are completed as in Demonstration 1, his nose as in Demonstration 3, and his mouth as in Demonstration 4.

I darken the background to tone 4 so it nearly flows into the dark shadow on the left side of his face. The shadowed side of his face is a combination of tones 3 and 4, which become gradually lighter near the face's center. In the midst of this darkness, the earlobe of his left ear is lighted slightly to show form, and tone 3 is used for this purpose.

The dark shadow on the left of his nose is a combination of tones 3 and 4, fading at the peak of his lighter left cheek. This highlighted portion of cheek is a touch of tone 2 softly fading into the shadows on either side of it.

I use tones 3 and 4 for his mustache and lay in his sideburns and hair with tone 3. A stroke of tone 1 to the right of his sideburn gives the necessary impression of his right ear. To define his jawline, a thin line of tone 3 is painted in and blended to achieve softness. The last thing I want is harshness; so I work to keep the tone soft.

As for his shirt, I simply paint over what was there, adding the folds where I see fit. I do this from my head, but unless you're fairly skilled, you'll do well to have the subject in front of you for rendering anything.

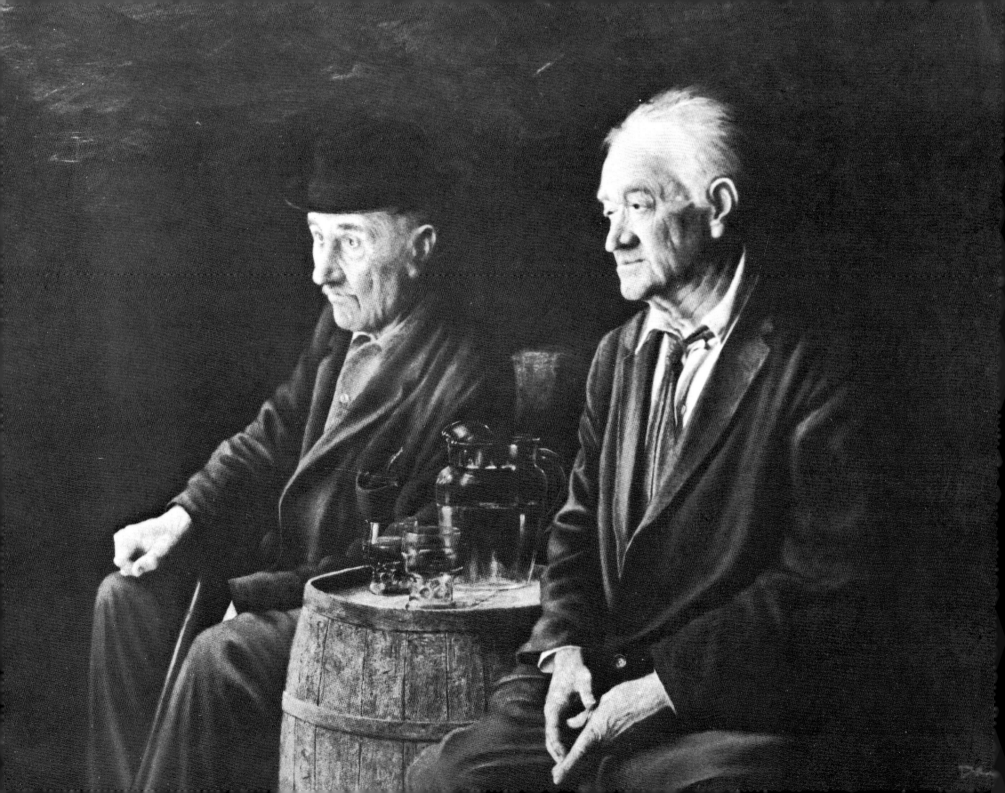

DEMONSTRATION 15: **THE OLDER MAN'S HEAD**

December Years, oil on board, 29″ x 39″. Collection Mr. and Mrs. Robert Sklar. The passing of time and subsequent old age provide the theme of this painting. Both men now seem to be caught in individual contemplation. They might be thinking of the years that have passed; the viewer is free to decide for himself.

I've generally found old men to be the easiest and most pleasurable sitters to paint. They're not as hampered by vanity or misgivings concerning their appearance as others may be. When a sitter becomes concerned with his appearance, his facial expression will be strained and artificial leading to sure disappointment for both the artist and the sitter. However, the usual attitude of the older man is that whatever's there, is there, for you to portray as you wish.

Certain features are especially interesting in old men. Primarily, the outstanding feature is their eyes. Frequently you'll see a twinkle or roguish expression there that's interesting and appealing. Often you'll find the key to the entire mood of your painting in the strong expression portrayed by their eyes. If you're careful and thoughtful, you can use this expressive feature to great advantage. Be sure that your painting's setting and your sitter's facial expression go hand in hand; if they don't, one mood will negate the other.

As men age, their eyelids often become very droopy — almost to the point of obscuring their eyes. This is a troublesome problem and one to be avoided if possible. It becomes your task to correct this to some degree. Work to have the eye visible, but don't overcorrect it.

You'll also notice many old men with large noses and large ears. Whether or not these features become larger with age, or their general facial structure diminishes making these features appear larger, is irrelevant. The relationship between the features and the facial structure is the important factor. Diminish the size of your sitter's nose or ears to attain a proper relationship with the rest of his face. This will avoid drawing unnecessary attention to a physical defect that might otherwise offend or embarrass your sitter and annoy or disturb the viewer.

Another noteworthy characteristic of old men is their prominent jowls. Again, you have artistic license to enlarge or diminish these jowls. However, you'll probably note that these jowls have a significant influence on an older man's visual appeal, and you'd probably find it advantageous not to obliterate them altogether.

All in all, you should find portraying old men a most challenging, satisfying, and tremendously rewarding project.

The Older Man's Head: Step 1. I thin tone 1 and use this to lay in the general outline of his head, his features, his hat, and the angle or tilt of his head as it relates to his body. I check the proportions of various features to make sure they're accurate. You may find it helpful to draw in a series of vertical and horizontal guidelines to capture these proportions correctly.

You'll notice that certain other aspects — besides features — are pertinent to capturing an old man's face. These are the shadow areas that represent the deep crevices and indentations that are so much a part of his face. Therefore, tone 1 is placed to show the indications of the jowl on the right side, as well as the creases in his forehead, his cheek, and by the side of his nose where his cheek is very full.

Tone 2 is applied for emphasis on the deepest shadows, such as under his hat. I also lay in his pupils with this tone. I show only the barest hint of his clothes at this time, since I want to concentrate my main efforts on his head alone to capture its essence accurately.

The Older Man's Head: Step 2. In step 2 I block in all the areas of his head with general approximations of the tonal values present. First, I work around his features, filling in the skin area with a combination of tones 0 and 1. This combination will represent his basic skin tone.

Different tonal values, other than shadows, appear in the skin tone. I represent these areas with the appropriate lighter or darker values, maintaining correct relationship with his basic skin tone. I use tone 3 for the prominent shadows, such as those around his mouth, his nose, and his eyes. The crevices around his eyes are much softer and, therefore, are represented with tone 2.

I lay tone 4 inside his mouth to illustrate that it's open. I advance his hat and coat by blocking in general tonal values in the same way that I've advanced his head. I do this so that the entire painting advances simultaneously. The advancement progresses far enough in this step to necessitate a background. I can't be sure what tonal value I'll want, so I've laid in a few varying tones around his head in order to choose well later on.

The Older Man's Head: Step 3. I've decided to take a few minor liberties with his face in order to produce a more interesting character. A sly, laughing look appears to be emerging, so I'll work to accentuate that. The immediate areas that I change to create this are his jaw, which I thin down slightly; a small tooth, which I add to his smile; and a bit more squint to his eye. The laugh lines of his eyes and his mouth are very important to his character, as is the angle of the corner of his mouth, which I accentuate.

The small tooth is laid into his mouth with an off-white. I place tone 4 around the tooth to represent the depth of his open mouth. His tongue is also in view, and is painted with tone 1; notice that he has practically no upper lip. I lay in a thin line of tone 3 across this area and blend it. I place a dab of tone 4 in the right corner of his mouth.

I capture the droop of his eyelids as in Demonstration 2. With a small brush, I lay in the laugh lines around his eye with tone 2 over the lighter color already there. A streak of tone 4 represents the pupil of each eye.

I use a combination of tones 3 and 4 to darken the existing shadow under his nose. This same tone is used on the left side of his nose next to his eye. Near white is placed at the top of his nose on the right side. His wrinkled brow is very prominent, so I go heavy on the wrinkles and use tone 3. If you find this too dark, it can be lightened later.

I continue to lay in the subtle tone changes. I place his jowls and wrinkles with tone 2. Lastly, I flip hair down from under his hat on the left side. This seemed to definitely enhance the sly roguish look I'm striving for. Of course, I'll tell you again to advance all other parts of this painting to the same degree.

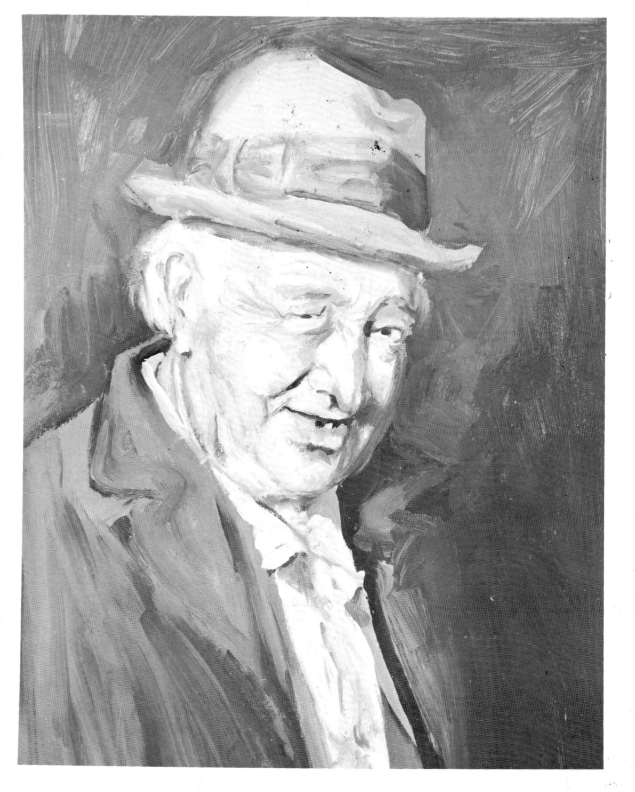

he lived at another "a few hours away." He would take us now to his house. We broke camp at once and followed him (opposite).

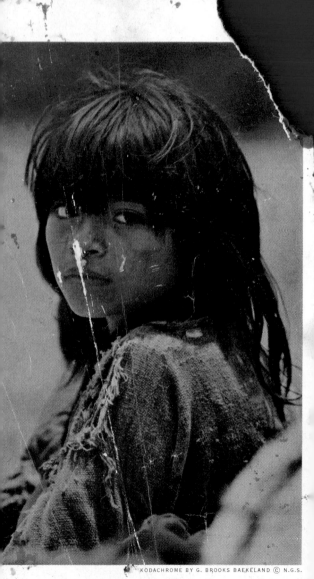

KODACHROME BY G. BROOKS BAEKELAND © N.G.S.

Silver nose pendant decorates a tattooed Machiguenga. Like the men of her tribe, she keeps her name secret. Although only 13, she has a husband and daughter. The family floated downstream on the expedition raft

The Older Man's Head: Step 4. The final refining touches — defining and blending — are now added. I refine and blend skin tones where I'm satisfied that I've laid in the proper tones. Refer to Demonstration 5 for completion details on the ear, Demonstration 10 for the hair, and Demonstration 3 for the nose.

After blending, I place a thin line of tone 3 carefully under his right eye to denote the bag seen there. Tone 0 is placed next to this line, since it's actually a rounded deep crevice. Notice carefully the light source. You can follow this same procedure of light tones next to dark ones for all crevices. In varying degrees this procedure captures the different depths encountered in various crevices.

I darken his tongue with tone 3 and place tone 4 on top of it for the shadow. Tone 0 is placed next to tone 4 on his top lip and blended for softness. His bottom lip is rounded by blending light tones into the darker lower area in the same manner as a rounded form shadow. Wrinkles of tone 1 are blended in, and then tone 0 is used for a highlight on his lower lip. I blend this highlight so that it won't be too prominent. Other highlights of tone 0 are placed on the bridge and the tip of his nose and in the dimple in his chin.

As I work to blend the neck area, I take care that my strokes are curved. The neck, naturally, is rounded and my brushstrokes will enable me to indicate this. I soften his jowls so they don't carry too much emphasis, and then I place tone 4 under his chin and blend.

For his hat and clothing, I place the tones in their correct positions and then blend. Under his hat I place a combination of tones 3 and 4 for the shadow there.

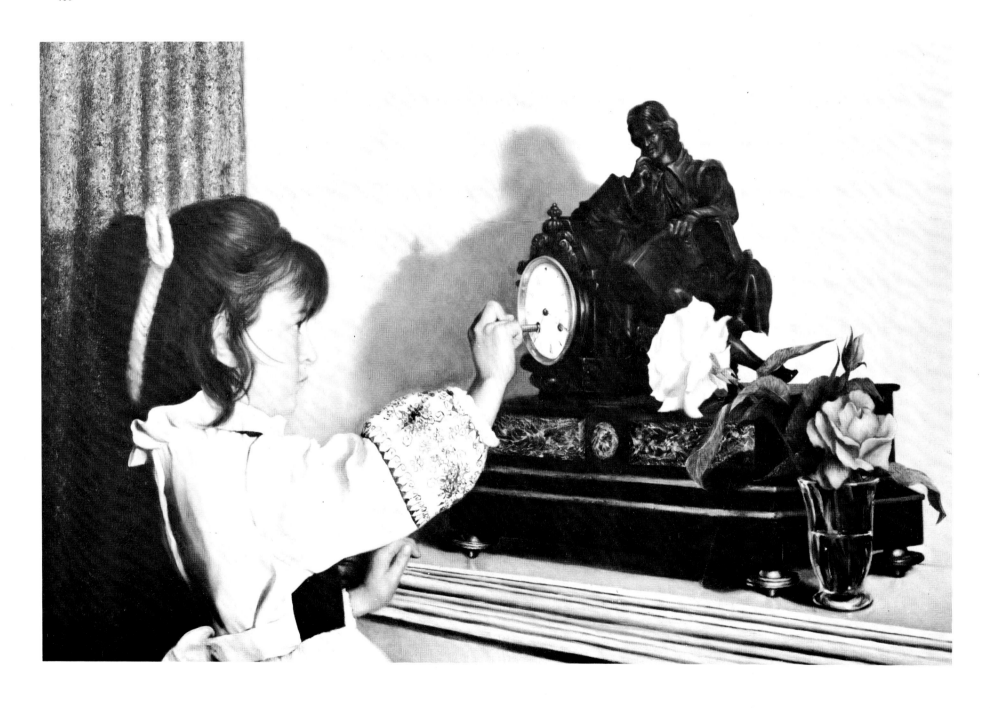

DEMONSTRATION 16: **THE CHILD'S HEAD**

Girl Winding the Clock, oil on Masonite, 20″ x 28″. Private Collection. Notice the intensity with which this child is performing her task. Her face mirrors her intense concentration. Attention to detail and a preciseness of rendering are the hallmarks of the technique used in this painting and further serve to underscore the theme of concentration.

A small child's face is a study of expressions that are uncomplicated by the complex inner emotions seen in adults. A child displays his true feelings with his face, and this is one of the qualities that makes painting children such fun.

Consequently, what you seek to capture in a painting of a child is expression — not impression. In other words, you're not trying to convey an impression of character, such as strength, gentleness, or even beauty. Character is developed throughout the years of childhood and beyond, so it's obvious you're going to have to find something else of interest in a child's face.

What a child's face does reveal in great quantity is mood. For instance, with every fiber of their being children can convey joy, contentment, admiration, or excitement. Every portion of a child's face radiates a given emotion.

I've found this to be delightfully advantageous but not without drawbacks. You aren't able to modify to any great extent the features of the child before you. If you modify them too much, you destroy part of the total mood portrayed by the subject's expression.

Due to these special qualifications and limitations of a child's face, I often — not always — prefer to use a somewhat brushy technique. This allows me a little more freedom with the child's features than is afforded with the more finished technique I prefer on other subjects. Aesthetically, too, I feel it's sometimes more in keeping with the constantly changing emotions of the child.

The Child's Head: Step 1. Due to the brushy technique I've chosen for this demonstration, each step will be somewhat less complete than the comparable step in other demonstrations. My final rendering of this child will be only slightly more advanced than step 3 of most other subjects.

With tone 1, I strive only to capture correctly the tilt of the child's head and the shapes and the proportions of her various features. I lay in the most basic representations of her features — just enough to enable me to judge their correct proportions and locations on her face. Her ear and hair are vaguely brushed in strictly for relationship and shape.

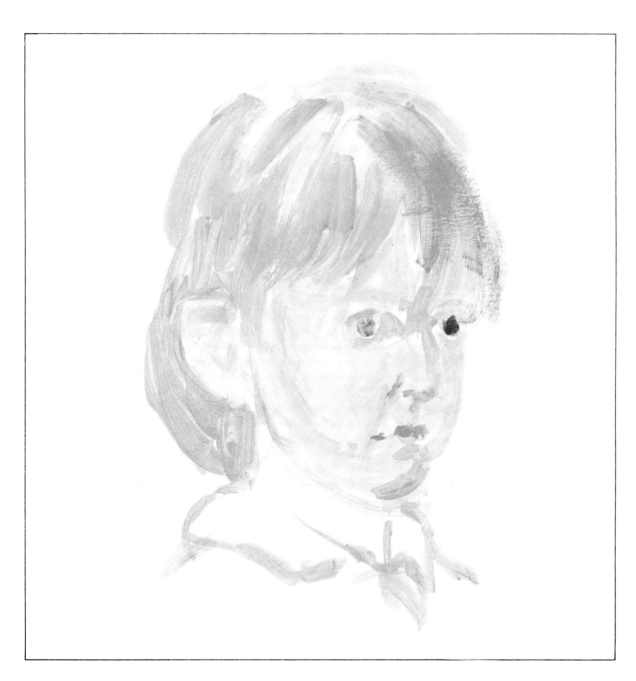

The Child's Head: Step 2. I'm beginning to define the features and add the major shadows now that I'm assured that all parts are correctly located. However, the child's features are still in little more than outline form at this step.

All of the facial skin tone area is filled in with a combination of tones 0 and 1. The pupils of her eyes are blocked in with a combination of tones 2 and 3. Her upper and lower lids are very loosely defined with tone 1 — just enough to indicate their shape.

With tone 1, I lay in the large shadows such as the one seen in her ear, under her mouth, and between her eyes; I indicate her nostrils with tones 1 and 2.

Her upper lip is shadowed slightly, so I render it darker with tone 2, with very little indication at all of her lower lip. Tones 0, 1, and 2 are all used as needed to lay in her hair.

The Child's Head: Step 3. Refinement of her features hasn't advanced too far due to my brushy technique, but in this step her features become more pronounced and their third dimension becomes a little more obvious.

Her skin tone remains basically the same with slight additions of light and dark. Even though her eyes are still blobs, tone 3 is brushed into her pupils to give them a little more depth. Her right eyebrow and her lids are darkened. I lay in white between the corner of her right eye and her nose where the light hits.

The large shadow above her nose is darkened very slightly with tone 2 and blended into her forehead and down by her nose. As you can see, this shadow is also extended under her left eye. The edges of her nostrils are also defined with tone 2.

I need to add a line between her lips, so I lighten her upper lip. Then, I add tone 3 under her lower lip for the shadow appearing at the top of her chin. Tone 2 is used to define her jawline. Her neck is brushed in with a combination of tones 0 and 1, and the dark shadow under her chin is tone 3. Tone 3 is added to her hair.

The ear shadows are deepened with tones 2 and 3. Because of the splashy effect of this demonstration, some of the ear detail can be deleted, but don't delete too much. You don't want it to be uninteresting.

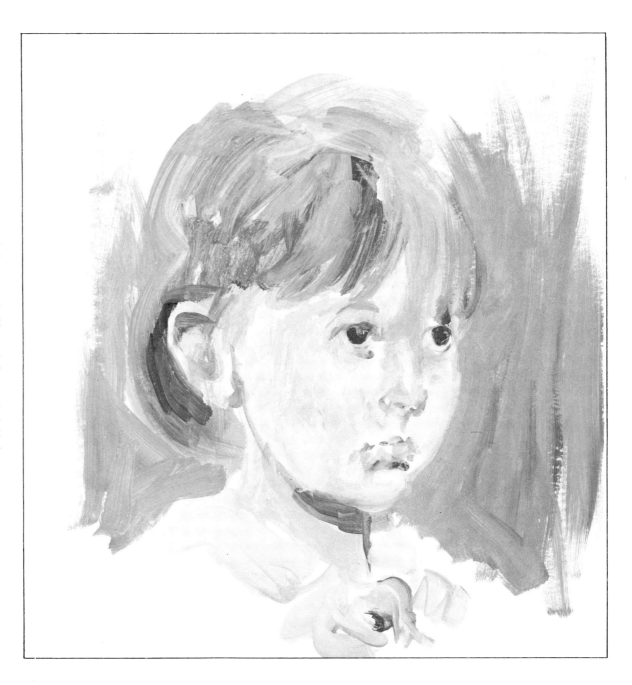

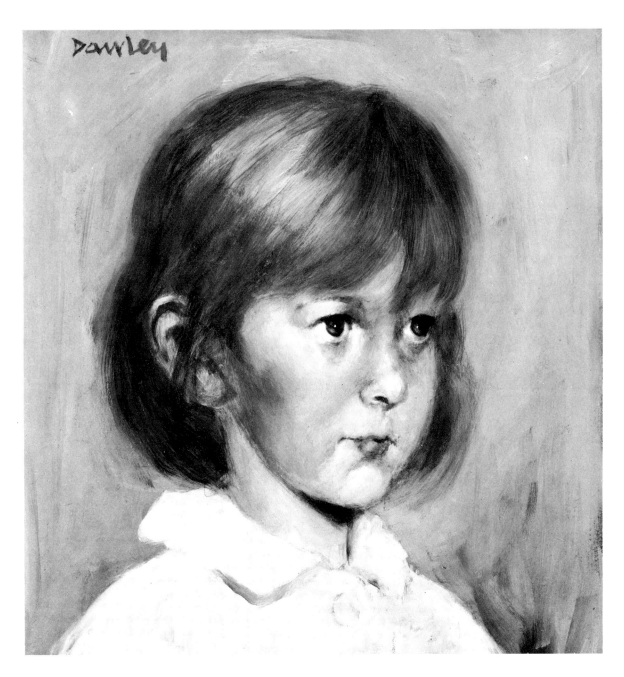

Dawley

The Child's Head: Step 4. I keep adding lights and darks to her skin tone, blending them until I've achieved the desired effect. Notice particularly the addition of a large shadow on her right cheek. To render this, I lay in tone 3 and blend it thoroughly. This shadow does a great deal to indicate her general facial structure. In addition, I blend in light shadows under her eyes which are also great indicators of facial contour.

I use tone 4 for her upper lashes and capture the translucency of her irises as explained in Demonstration 2, step 4. At the top of the bulbous portion of her nose, I blend in a small amount of tone 2 to accentuate its slightly pug quality and unformed bridge. This type of nose is often found in children.

A combination of tones 3 and 4 is used for the line dividing her lips. Notice that this is never a straight line; it's disconnected at various places in order to look natural. I carefully turn the corner of her mouth slightly upward to avoid the sullen look that would have occurred otherwise.

I tone down the shadow above her chin and blend it well. All of her facial shadows are well blended, even in this brushier technique, but not carried to a high degree of smoothness.

The shadow under her chin is a combination of tones 3 and 4, and its edges are softened to avoid harshness. Being a cast shadow, further blending isn't necessary. Her ear is completed just enough to blend well with the rest of her face. A few bright highlights are added on her face with tone 0.

All the tones on my palette are used in various places for her hair. The tones are simply brushed into each other, as opposed to blending, to produce the effect of her hair. The outer edge of her hair is brushed back and forth into the background for a nice, soft look. To complete the background, I use tones 1 and 2 combined. These are selected because they offer good contrast to her head and her hair.

COLOR DEMONSTRATIONS

DEMONSTRATION 17: **THE OLDER MAN'S HEAD**

The majesty of human features — whether sublime or misshapen — is missing in much portraiture. One reason is that portrait heads are often overworked. Trying for an exact likeness sometimes causes the painter to build up layers of paint around features, giving the painting surface an ugly appearance. What's worse, this often results in a forced expression. Even though I may *choose* to paint the exact features of my sitter, I prefer never to be bound to an exact likeness — either by a commission or by my own attitude. Simply producing a likeness is by no means the peak of success in portrait painting. When you walk through a museum, you'll note that great portraits are masterpieces for many reasons — they're well executed, inspiring, well designed — but not solely because they capture an exact likeness.

All I'm trying to say is that your main objective should be to paint what *you* consider a beautiful head. If you can accomplish this by painting the features exactly as they are, then a likeness *does* become important and necessary.

But if it seems necessary to alter what's before you to create a beautiful painting, then do so! Allow your imagination the freedom to amend your subject in order to achieve your goal.

However, I want to make it quite clear that any changes you make in the sitter must be done on purpose and with skill — not because of inadequate draftsmanship. You need both knowledge and drawing skill to change an exact likeness for the better. Don't make a change just to cover up an error!

For example, I made a very slight change for the better in the model's features in *The Girl with the Apple*, page 13. I felt that the model's nose was slightly too large, and her chin was too strong. Making minor adjustments on them, I got just the saucy look I wanted — a young girl turning her eyes toward the onlooker after taking a bite from an apple. The only other change I made was to lengthen her fingers slightly for additional grace. I think nothing is more graceful than long, slender fingers on a pretty, young girl.

Keep in mind that your total composition will probably denote some type of mood. The concept of mood may sound a bit complex, but it's not really. Mood is merely your own emotional reaction to your subject which is conveyed by your painting to the viewer. Adjectives such as calm, happy, joyous, quiet, serene, nostalgic, and gracious are but a few that might denote the mood of a painting. Therefore, you'll want your choice of sitter to be harmonious with this overall mood.

Now for a few general comments on a man's facial tones. Caucasians are basically redder in the nose and cheek area, slightly yellowish in the forehead area (a touch of yellow ochre to the skin for this). There's a more greenish and grayish tone around the lower portion of their faces where whiskers or a five o'clock shadow may be present. The center of a man's chin is basically pink, fading off into gray in the whisker area.

The following demonstration explains the actual mechanics of painting in color a character study of an old man's head.

The Older Man's Head: Step 1. To begin with, I make sure that my gum turpentine is clean. Then I use my palette knife to mix burnt sienna and white to create a color similar to skin tone. During this first step, I use three shades of this color to create the basic drawing. I'll call this approximation of skin tone the "basic color." Next, I mix white and burnt sienna again — this time with much more burnt sienna — to get a much darker tone, which I'll call the "dark basic color." Then, I mix a lot of white with a small amount of burnt sienna to get the "light basic color." Now I have a three-color (or three-tone) palette. My last two additions to this palette are separate little mounds of titanium white and burnt sienna. This is the way I start practically every painting.

I cover his entire face and hair with the "basic color." I hint at his features and hairline with my darker and lighter basic colors. I suggest features in a sketchy manner by indicating shadows. It's not good to think of the mouth, the eyes, the nose, etc. as individual entities. The features should be regarded as abstract shapes which when properly put together will produce a head. I try to include all the shadows first; then I begin hitting the lightest areas to bring out form. Using gradations of burnt sienna and white, I start forming details such as jowls and deep crevices. At the same time, I add highlights to denote the lighted areas of his face.

For the background, I use a thin layer of burnt sienna diluted with turpentine. The man's coat is laid in with a thin layer of the dark basic color; his tie is a thin layer of burnt sienna, and his shirt is simply white. Now I have a three-tone piece that's captured the essence of my sitter.

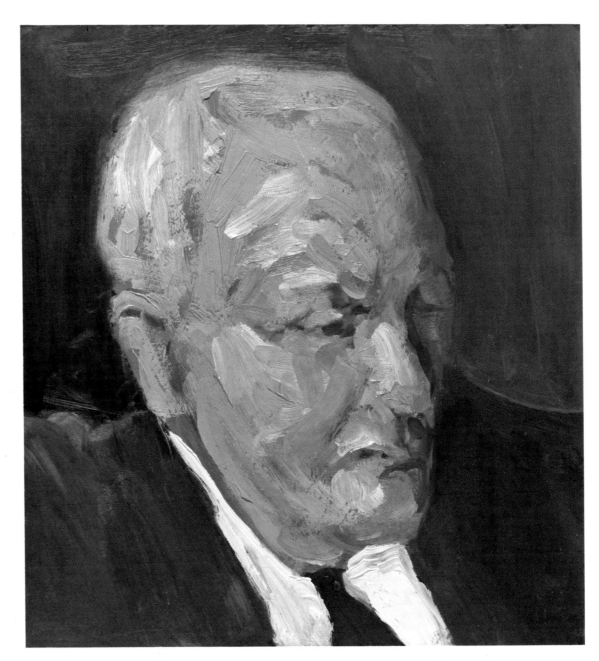

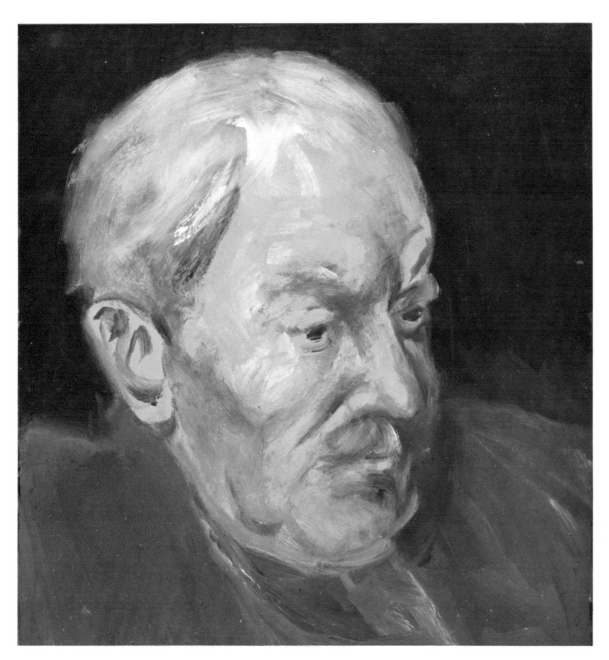

The Older Man's Head: Step 2. On my palette I mix ivory black and titanium white to produce a cool gray. I use this color on his whisker shadows and his eyebrows. At this point in this demonstration I begin to develop an ordinary man into an older, more interesting character study. A few strokes denote his hair falling onto his face; I add a gray mustache which seems to fit his character. I paint his eyebrows a little bushier, and now I have the makings of a much more interesting character study.

On a *separate palette* I place yellow ochre, ivory black, burnt sienna, cadmium red, and phthalocyanine blue. I mix burnt sienna, blue, and yellow ochre to obtain a warm brown for shadows. There is much more yellow ochre than the other two colors in this mixture; I mix up plenty. Then, I take half of that brown and mix it with ivory black for a cool, strong shadow color. I take half of that cool mixture and add burnt sienna for a deeper, warmer tone. Now I have three brownish shadow tones — my final ones. When using these shadow tones, I apply them thinly; heavily painted shadows look unnatural. I mix cadmium red deep, yellow ochre, and white for a pink skin tone into which I blend the shadows. As a final preparation, I place on my palette a dab of alizarin crimson next to a dab of white in case I want the alizarin later.

I start filling in shadow areas with the shadow tones. I paint his mustache with shadow tone until I decide on the final color for it; then I add a touch of color to his hair. Finally, I rub out his shirt and tie and brush burnt sienna in their place. His clothing needs to fit the more casual mood that's developing. Therefore, his shirt and tie appear to be a bit out of character.

The Older Man's Head: Step 3. His features continue to become more prominent through more refined blending which strengthens their form. I highlight his wrinkles; the stronger the highlight, the deeper his wrinkles will appear.

I brush yellow ochre and white into the light area, except for his lip. I highlight his lip with cadmium red deep and white, which I brush over the burnt sienna already there. If the upper lip were showing, it would be darker than the lower one, because the upper lip is always in shadow. It's usually desirable to paint lips slightly redder than they actually are; this holds true whether the model is male or female.

I work some more on his hair, showing more of it falling onto his face. To help create its natural look, I blend the hair back and forth into the background.

I begin to work on the background, using a mixture of yellow ochre and black. Whatever background you do, get away from the burnt sienna you start out with. It's only a preliminary step; the redness simply doesn't complement skin tones. I'm careful to work my skin tones from the edges of the face into the background to avoid a harsh line where face and background meet.

I decide that a coat and sweater are more appropriate clothes for this character, so I lay them in more clearly. Into the burnt sienna already there, I brush a minute amount of phthalocyanine blue with black to get the color of his sweater. This same combination of blue and black, with the addition of yellow ochre, gives me the greenish tone I want for his coat.

The Older Man's Head: Step 4. During this step, I'm working to create the final look of the character. You'll notice that his jawline and neck are now slightly different. As his character evolves, I widen (or fatten) my sitter's neck to age him a bit more. His fairly heavy jowls have been present from the beginning and his facial line could have easily remained the same, but I decide to make this additional change.

I note an unpleasant bulbous shape to his nose, so I correct its line. I add wrinkles by blending shadows and highlights along the wrinkle lines. I work to have his eyeball take form in the socket as in Demonstration 1. I define the ear as in Demonstration 5. I build up his hair and blend it back and forth into the background for softness. Don't forget that overhanging hair will cast a shadow on the forehead. Check your light source carefully so that the shadows will be cast in the right direction. I complete work on his lip and add a final highlight of alizarin and white; this produces a cool highlight to contrast with the warm skin tones. I touch the other facial highlights lightly with a mixture of yellow ochre, white, and black.

Now, I put the finishing touches on his coat. I define its lapel, using ivory black as the darkest tone for its deep shadows. Then, I brush gray (a mixture of black and white) all over the coat and allow the gray to fade into the background to avoid harshness. I add a touch of gray to the corners of the lapel to show its shape more clearly. Finally, I use the shadow tone mixture to distinguish between his shoulder and the background.

For this particular character, I still want something. Suddenly I realize it's a pipe. I brush the pipe lightly into the dark area of his coat, using my original shadow tone mixture. The pipe barely shows up at this point, so I begin to define it by adding yellow ochre in the stem and bowl where the light would hit. Then, with a mixture of yellow ochre and white, I define the pipe's highlights.

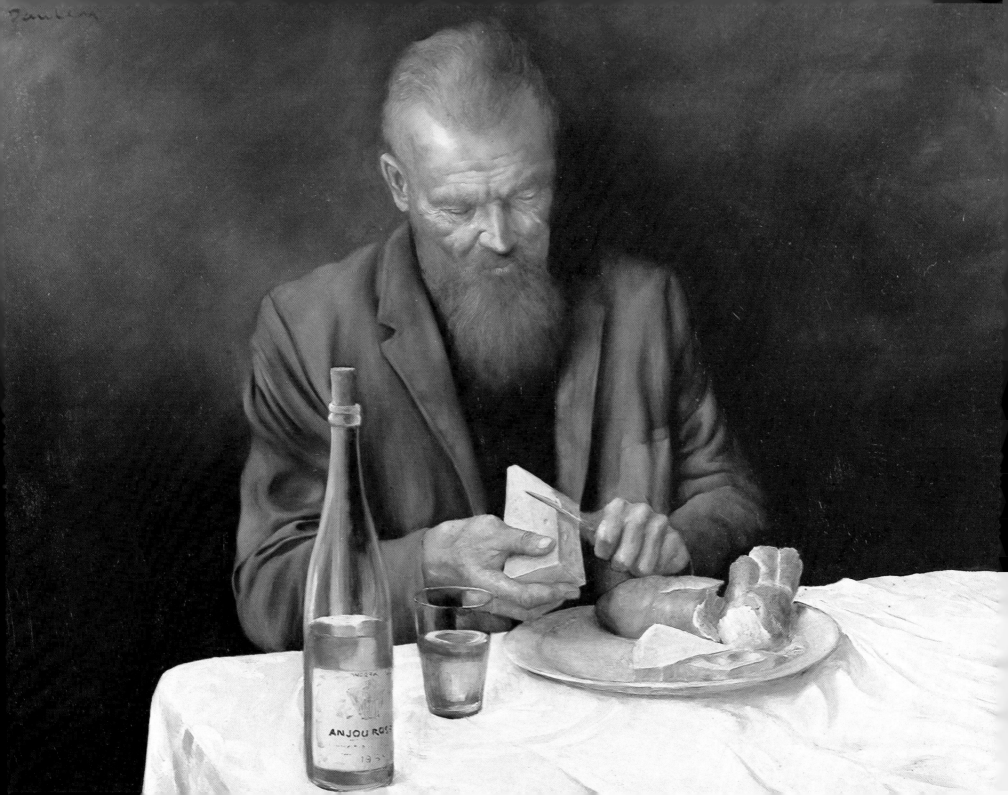

DEMONSTRATION 18: **THE MALE HEAD AND HANDS**

Bread, Wine, and Cheese, oil on Masonite, 28″ x 39″. Collection Mr. and Mrs. Raymond Zeltner. This is an all-time favorite subject with artists — a man enjoying bread and wine. It would be somehow more commercial — and less aesthetic — to have the man eating, say, a T-bone steak. Of course, if handled properly, this could make a good subject also. The red wine complements his ruddy complexion.

I've chosen a middle-aged man as my subject matter for one very obvious reason and several that are less obvious. The principal reason is that I wanted to vary the format here from the regular four-step study to a condensed three-step study of the middle-aged man; in the fourth step I drastically age the same subject.

The ability to render this change isn't only interesting and challenging, but extremely helpful on occasion when your "perfect" subject isn't the perfect age for your requirements. To search for a character with certain qualifications and physical attributes is limiting enough without attaching strict age limitations also. After all, your subjects should provide impetus and inspiration for your work rather than limitations.

However, as I've mentioned previously, I don't advocate radical changes just for the sake of change, but rather by necessity. It's always preferable to have the perfect subject from which to work, but when this is impossible, the project doesn't need to be discarded if you have a subject available who can be used advantageously by changing his age.

I've also chosen this younger man because I find his coloring particularly pleasing. My favorite skin tones appear in complexions that are directly between fair and swarthy. The colors in this complexion type are varied and clearly differ from each other. In a complexion that's extreme in any manner — such as very pale, very swarthy, etc. — the colors are all quite similar to each other. They tend to lack the contrast that, to my mind, has so much to do with the creation of beautiful skin tones. Even though I don't like too pale a skin tone, I lean more toward the pale rather than the swarthy complexions. With these *paler* skin tones, I can produce a translucent appearance that makes an especially beautiful painting.

As a former caricaturist and cartoonist, what I've done in step 4 was extremely enjoyable — outright fun. I don't expect it to strike everyone in that same manner, but I do hope you derive some enjoyment and benefit from this change-of-pace exercise.

The Male Head and Hands: Step 1. Since this portion of the demonstration is completed in three steps rather than four, you may find it advantageous to check the other color demonstrations for more precise details on mixing the skin tones. I've limited my descriptions to deal fairly exclusively with the skin tones, with only token references in step 3 to other areas.

Also, I've deviated here from my practice of advancing the painting as a whole — a practice I've recommended for the less experienced artist to enable him to know where he stands at all times. However, for an advanced painter it's helpful to lay in a solid color foundation on the face and hands with only outlines for the rest of the painting. If you're advanced and have captured the basic skin tones well, the other areas will be no problem. You also eliminate the possibility of other, well-rendered areas influencing your ability to determine whether the correct skin tones have been achieved. This procedure prevents you from becoming too committed and unable to quit when you should.

My palette consists of raw umber, Venetian red, and white. The red and white are combined to make two mixtures — a light one and a dark one. I use these colors to draw the basic shapes, positions, and proportions of his features.

His features are completed fully enough to be quite clear, since this is the time to work out drawing problems — not later. General body motion and characterization should be captured fairly accurately, so that by the time I've completed this step, a firm rendition of my subject has emerged. Then, I have a good idea of the direction in which I'm heading.

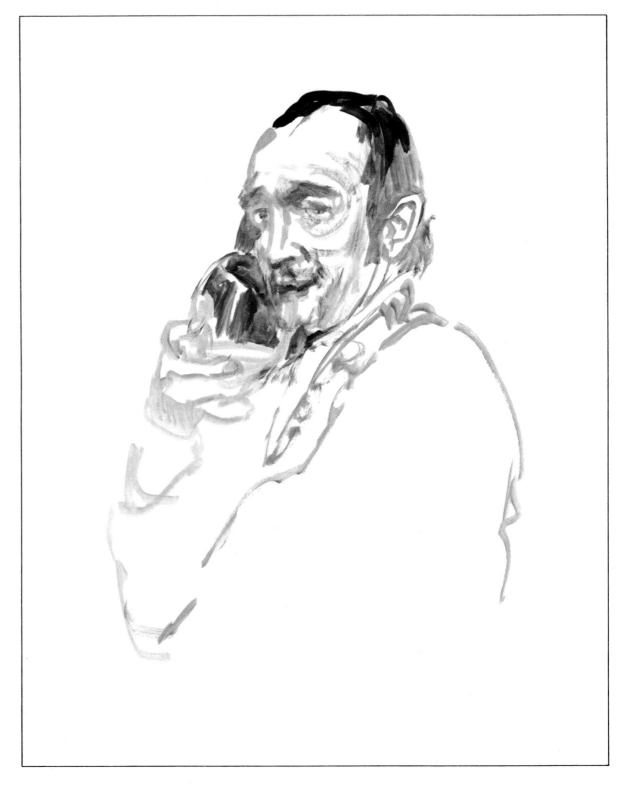

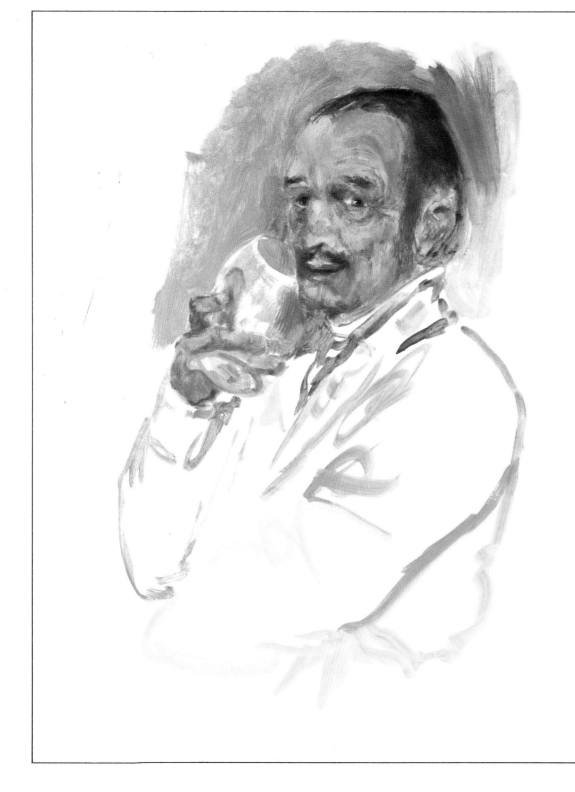

The Male Head and Hands: Step 2. On my palette I have a mixture of raw umber and white which produces a rather dark-toned gray. I also have a mixture of ivory black and white which produces another gray, but one that is cooler and lighter. I also use burnt sienna, and a mixture that consists of yellow ochre, white, and Venetian red; this produces a light yellowish skin tone.

My basic skin tones are Venetian red and white, and the combination of Venetian red, white, and yellow ochre. I use these colors to model the skin tones. Form is given to the ear with the Venetian red and white mixture which I use in the shadow areas. I use this mixture instead of burnt sienna, because if this area should dry before you get back to it, you might find it difficult to work over the burnt sienna.

You'll notice that the skin tones are quite bright in this step, and I find this a distinct advantage. It adds interest in an early stage and gives a good base on which to slowly work over and develop the fine points. His hand is rendered with Venetian red and white, with the shadowed areas captured by very thinly applying raw umber.

Grays are added to his face at various points. The bearded area is primarily the gray produced from raw umber and white. The same gray is used in his left eye socket and for creases. The "black and white" gray is used in these shadow areas as a contrast and for emphasis. This color is particularly helpful for this purpose. The shadowed right side of his face, however, isn't gray, but the same thin raw umber which I apply in the same manner as I did for his hand.

"Black and white" gray is used for his iris, with raw umber dabbed in for his pupils. Burnt sienna and raw umber are used between his lips; burnt sienna is brushed lightly into his upper lip. All the hair areas are raw umber, but whatever you do, don't let this raw umber dry before you're ready to complete work on his hair. A thin coat of raw umber and white is used for a roughed-in background.

The Male Head and Hands: Step 3. The constant working and reworking to refine all the skin areas has lowered the brightness of the tones seen in step 2. Much of this has to do with the use of grays in the skin tones and the placement of highlights. The gray produced from black and white is used extensively around his face — on his forehead, by his nostril, around his eye, etc. Raw sienna is added in his five o'clock shadow areas, along with the "black and white" gray for contrast. His little goatee is raw umber. I brush raw sienna and the "black and white" gray into the raw umber of his hair.

I lay in a new highlight tone on his forehead and in the inner corner of his eye. This tone is a combination of ivory black, white, and yellow ochre. Another highlight color I use, seen on his nose and cheekbone, is Venetian red and white. After the paint is tacky, I brush the white and yellow ochre highlight lightly into these two warmer highlights. The crevices in his fingers and those by his eye are done differently. The bright original skin tone of his fingers is left exposed while yellow ochre and white are worked into the remaining portions of his fingers along with raw sienna and the "black and white" gray. Around his eye, I brush in the light streaks and then lay raw umber and white alongside them for coolness. However, I'm very careful with the raw umber and white, because they'll muddy the skin tones if carelessly applied.

In order to capture the shadowed back of his hand, I glaze the background color into this area and then come back in with raw sienna and Venetian red for texture. His iris is painted with raw sienna to give it a brownish cast and later is glazed over with raw umber for translucency. The lower lip is basically Venetian red and white.

The following colors are used in the smoking jacket: Venetian red, raw umber, permanent mauve, and white. A little of this color is flicked into the glass to give the essence of glass and its reflection. The lapel is glazed over lightly with rose madder genuine.

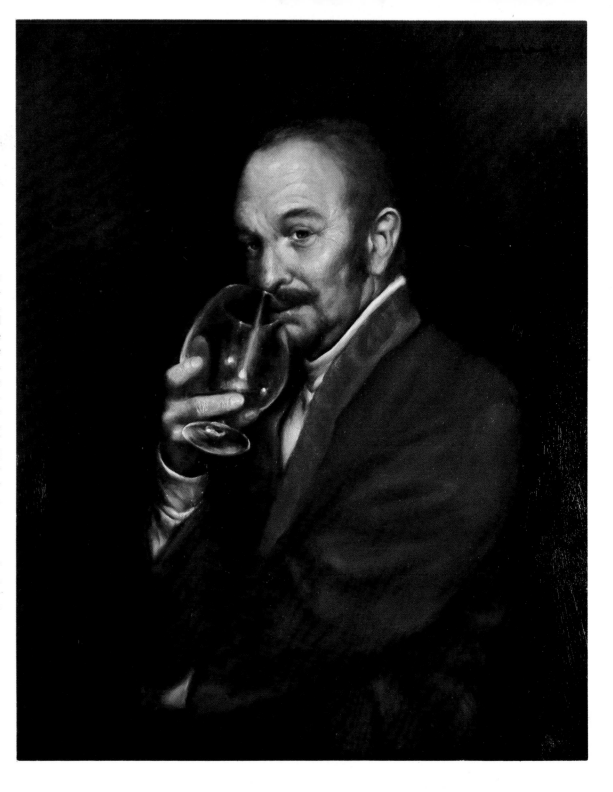

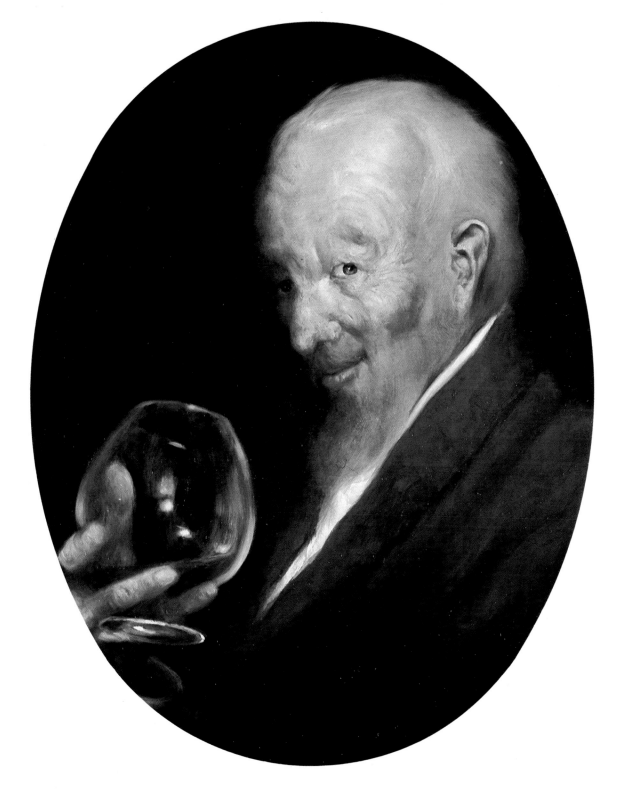

The Male Head and Hands: Step 4. This step is different from others in the book in that it's a completely different painting. It's a demonstration to show how you can use the same sitter to create a different painting and achieve a different effect.

In addition to aging this character, I've lowered the glass and changed the tilt of his head slightly.

First, the brushstroke I use is freer, because it helps to depict the sitter's old age. His basic coloring is the same, except that I've deleted some raw sienna to achieve a somewhat paler complexion.

I've accentuated the reddish areas with Venetian red, because these tiny vessels often surface in age giving a reddish glow. Also, the gray areas are emphasized more highly, creating deeper hollows.

His eyelids are drooped and wrinkled with a gray produced from black and white. I use this gray quite prominently to capture this wrinkled effect.

I've added many wrinkles around his eyes and sagged his skin at my discretion, just as I would with an actual model where I add or delete wrinkles according to my own judgment.

I use "black and white" gray on his left temple to indicate a large protruding vein. This is a practice of mine since it is so commonly seen and is very typical of old age. By using a small brush, I apply a dab of Venetian red with a dab of white next to it; this produces small pits in his cheek and nose. His hand is aged in the same manner as his face.

As for his ear, you'll often find that ears lose shape with age and can become almost grotesque. I don't change the shape of his ear much, but I've added Venetian red for its veins.

I've added a beard, changed his mustache, and grayed his hair. The colors used are two different brands of raw umber mixed with white, and a little ivory black and white mixed in. This same combination is used for the eyebrow which you can see has taken on a much different shape than it had in the younger rendition of step 3.

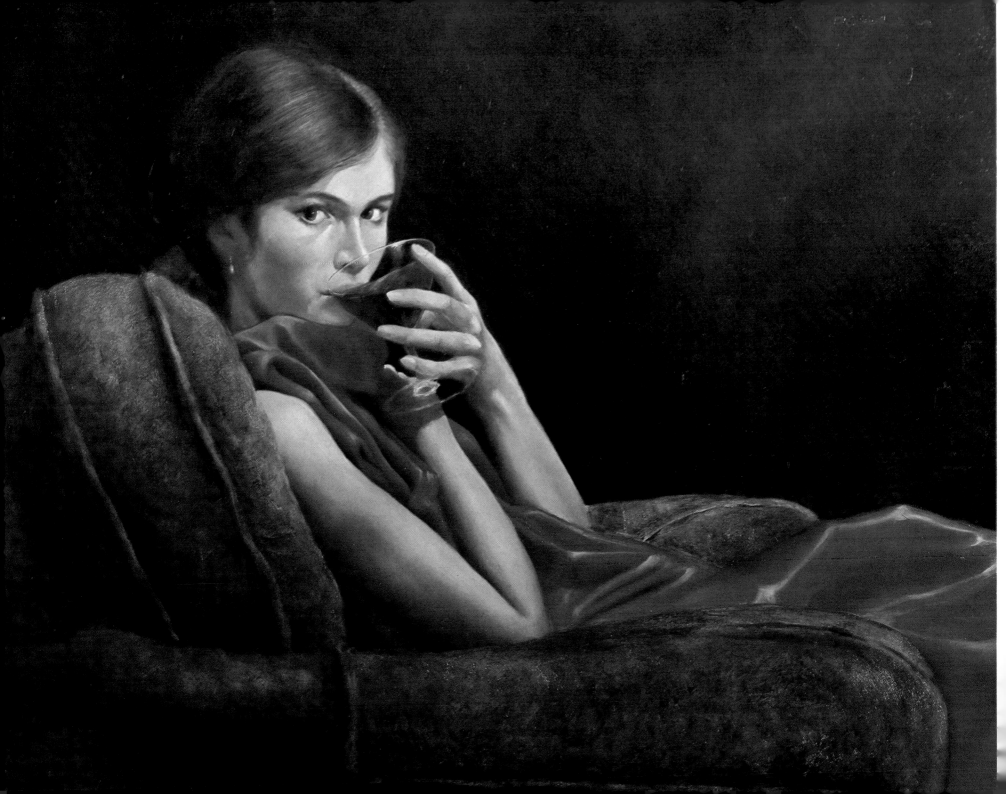

DEMONSTRATION 19: **THE FEMALE HEAD AND HANDS**

Girl in Red, oil on Masonite, 23" x 30". Collection Mrs. Shirlee Rauch-bach. I don't like to use red in any great quantity with skin tones; it usually doesn't work out well. However, this time it did. The muted orange of the chair along with the deep purple of the wine offset the red dress. These supporting colors complement the model's skin tones quite well.

The combination of the right woman's head and hands can be an elegant study indeed. Together they can portray the epitome of femininity and be the equal of any other subject matter for interest, charm, and appeal. However, the right combination isn't easily found. As I've stressed in other areas of this book, the hands and the face must complement each other in both their physical characteristics and in their portrayal of mood.

Not only must a woman have the appearance you desire, she must be able to move with grace to get into useful poses. Occasionally a woman will just sit and that will be sufficient. However, in most cases the needed interest is added by having her doing something that suits the mood you're seeking. Besides displaying action, you may find that an added prop is exceedingly useful in rounding out your painting's design or adding a needed touch of color.

When you find the model that's physically close to what you want and handles things well, you can alter her features carefully and achieve quite delightful results. I don't advocate much alteration, because a woman's appearance is too delicate to allow much tampering, but her fingers may be lengthened or her nose shortened, etc. with success.

For example, in The Girl with the Apple, page 13, slight modifications on her face had to be worked in to enhance the basic beauty already there. Her nose was slightly modified and her chin was shortened to get just the effect I wanted. In Girl with Creme de Menthe, page 46, her position and expression were fine, but her fingers required slight elongation.

The subject for this demonstration required no facial changes at all. Therefore, I was able to concentrate on rendering her without worrying about difficult alterations.

The Female Head and Hands: Step 1. My palette for this beginning step is very limited indeed. Basically, I'm working with two colors, but I've laid out three since one of the two is a mixture. My palette consists of titanium white plus a mixture composed of Venetian red (see Materials and Methods), yellow ochre, and titanium white. The reason for the use of this mixture, which produces a deep pinkish color, is that it can be easily painted over, even when dry, due to the low oil absorbency of all three colors. It's obvious that the colors used in the primary steps of a painting must lend themselves to this type of change.

Using these two colors — titanium white and the deep pinkish color — I work to lay in the basic outline, shape, and proportion of her head as well as its tilt. It's important to establish these elements correctly before proceeding further.

Some painters like to blot the painting at this stage with paper or a paint rag to keep from getting too heavy a build-up of paint at such an early point.

I tentatively draw a circle around my subject in pencil. I've chosen to place my subject in a circle because of the many ovals within the painting itself. Of course, this device is one that you can employ at any time. When placed within an appropriate shape your subject can produce startlingly pleasant results.

The Female Head and Hands: Step 2. I add one more color to my palette — raw umber — and it gives me all the colors I require to complete this step. I fill in the entire canvas and give basic form to everything in the painting, delineating its circular shape.

My mixture of Venetian red, yellow ochre, and white is used in varying degrees for her basic skin tone. It's not used as a flat color; varying amounts of each color predominate in the mixture as necessary to produce a basic form in the skin tone areas. Since my palette is so limited at this point, I also use this pink tone for the pillow, even though it will ultimately be a far cry from pink.

Raw umber is mixed with varying amounts of white to produce the grays seen here. The background, hat, couch, hair, grapes, pillow decoration, and dress folds are all this pink combination in varying strengths. This color is also used very lightly for shadows on her face and her hands. Her eyes are worked in with raw umber and white, and her lips are formed with Venetian red. White is brushed in roughly for her dress, and its major folds are placed with the above-mentioned gray.

The Female Head and Hands: Step 3. For this step only, I zero in for a close-up detail of her face and hands. Of course, you would work the other portions of the painting up to this point of completion before proceeding further.

Raw sienna and ivory black are added to my palette in this step. Due to the importance of her skin tones, I'm very careful to keep the palette containing my skin tone colors separate. Therefore, I lay out "another" palette which contains aurora yellow, ivory black, titanium white, and raw umber. The yellow and black produce a vivid green; white is mixed into this combination to achieve both proper tone and opaqueness. A little raw umber is mixed in when it's used on the grapes. I avoid striving for perfection in this step. I'll probably want to make a few changes and would hesitate to do so if the area was in a perfect state.

I start modeling various skin tones into the basic tones I've already laid in. Besides the obvious reds and yellows, I consider grays most important, especially in the delicacy of a young woman's skin tones. I use a combination of ivory black and white with raw umber to produce the cool grays found predominately above her nose, around her eyes and her mouth, and in the light shadow areas. A combination of yellow ochre and white is used for highlights such as those seen on her forehead, her nose, and her cheekbones.

For her eyes, I use ivory black and white with a touch of aurora yellow to create the green of her iris. You'll notice that her iris is darker near the white of her eye and lighter near its pupil. This touch is great only if you can render it well, but it's not necessary if you fear you'll ruin what you've already done. The lower rims of her eyes have a pinkish cast which I achieve by combining Venetian red with white.

The subtle color of her hat is a combination of raw umber, aurora yellow, and a little black.

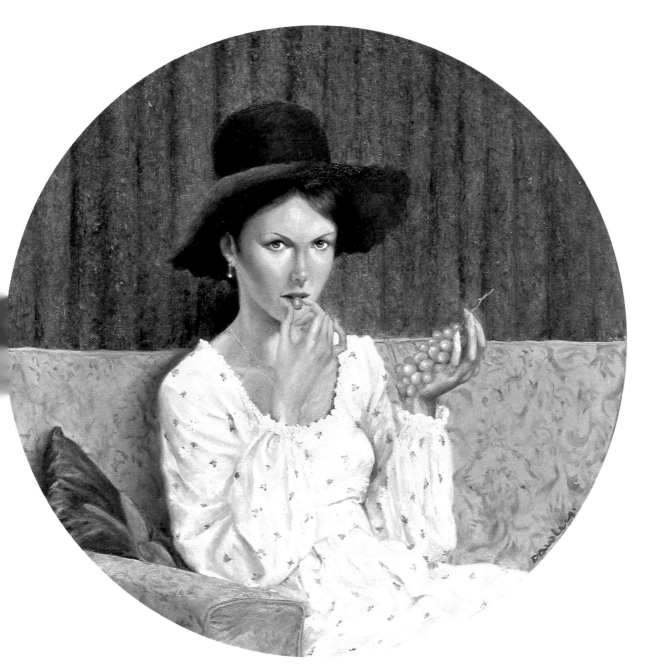

The Female Head and Hands: Step 4. To complete my palettes, I add viridian and cobalt blue to my non-skin tone palette. Before starting my final refinements, I make substantial changes in her hands. On her right hand, I raise her little finger for emphasis and grace. Her left hand appears confused with the exposure of its first finger, so here I delete that finger. Now I'm ready for my final touches of color.

I work Venetian red into the skin tones. As a final touch on her right hand, I use a gray, produced from black and white, to portray its veins.

I decide to change her eyes from green to blue so I add cobalt blue and white in her irises. Also I add a very pale mixture of Venetian red and white in the inner corners of her eyes. I use a combination of yellow ochre, white, and black for the cool highlights which are placed next to the warm skin tones. I deepen the darkest shadow under her chin and lighten the remaining shadow in this area. I'm very careful to avoid harshness. Her jawline is lightened to produce a more pronounced high cheekbone.

Her hair is rendered predominately with raw umber; yellow ochre and white are used for its highlights. Viridian, raw umber, and aurora yellow are used for the pillow with white mixed in for its highlights. Yellow ochre and white are the basic colors for the decoration.

The basic color of the couch is raw umber and white which produces a dull, pale green. The design on the couch is loosely applied, but unless you're quite skilled, don't try it. A poor rendering of it would be quite disastrous. I paint in the folds of her dress with ivory black and white; its roses are dabbed on with Venetian red and white.

As you'll note, I also decide to change the position of the grapes to create a more pleasing effect.

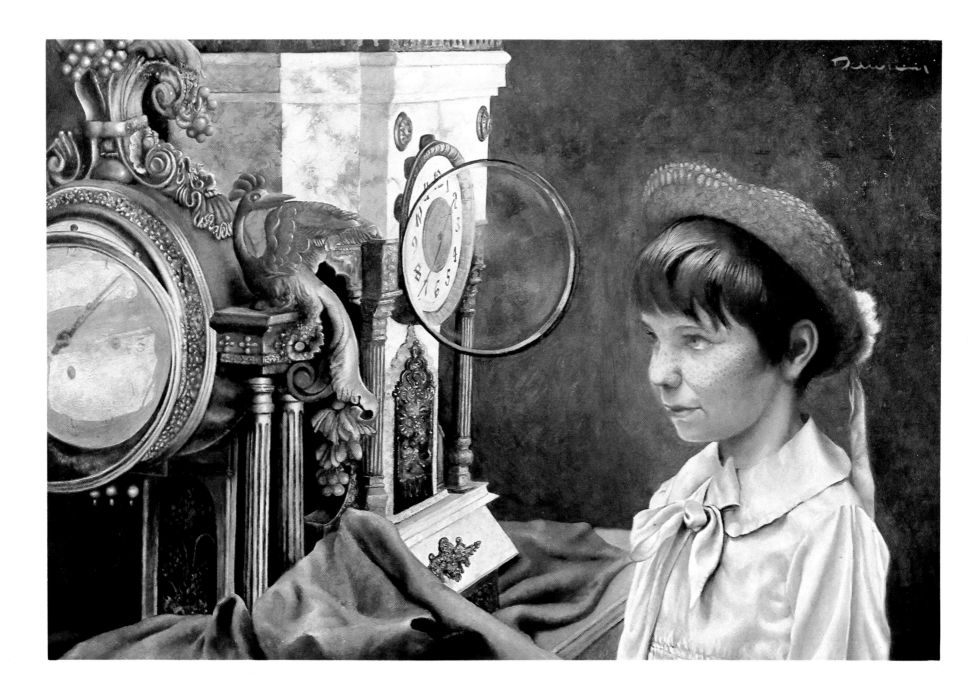

DEMONSTRATION 20: **THE YOUNGER CHILD'S HEAD**

Deborah and the Clocks, oil on board, 20" x 30". Collection Mr. and Mrs. Donald Widdows. Although at first she seems overshadowed by the grandiose old clocks, the little freckle-faced girl becomes increasingly important as you gaze at the painting. Part of her appeal is generated by the interesting clothes she wears.

The skin tones of a very young child are as fresh and untouched as the child himself. Such elements as weather, or even stress, can redden, pale, or line complexions as a person grows older. However, none of these factors has, as yet, had an effect on such a young child.

And, of course, you're seeing another striking characteristic as you look at a child's face. A baby's skin has a distinctively soft and smooth texture that's readily noticeable. To illustrate the importance of this texture, consider how the surface movements of different materials vary. For example, cotton hangs differently than taffeta, etc. So it follows that the way in which a baby's skin moves is a visual manifestation of its extremely soft texture. In other words, you want the viewer to sense something special about a baby's skin and to be able to see its softness. There's absolutely no harshness at all in a young child's face.

This lack of harshness extends into the child's facial expressions as well as facial texture. The beauty of youthful innocence and the eagerness for life itself are written all over children's faces. An experience is all encompassing to a child and commands his entire attention even though the interest may be very fleeting.

Even the hair of a youngster differs in texture and character from that of an adult. When you hear about "baby-fine" hair, that's exactly what it is. You must strive to capture its fine untampered quality.

It's these textures, expressions, and emotions — openly conveyed as only a young child can convey them — that make painting children exciting to the artist and to all who see the finished painting.

The Younger Child's Head: Step 1. Right at the beginning I want to explain that I use lapis lazuli, the blue of the old masters, in this painting. It's well simulated by a good brand of French ultramarine which costs less than 1% of the dearly priced lapis lazuli and is also easier to manipulate. I'll refer to this color, therefore, simply as ultramarine.

I don't use the brushier technique I've employed with the older child in Demonstration 16, even though it would have allowed me to more adequately capture the fleeting nature of the child's expression. Instead, I've chosen to sacrifice a little of this spontaneity for more smoothness due to the delicacy of this younger child.

I've combined Venetian red, yellow ochre, and white to produce the basic skin tone; the other color I use in the dress area is a combination of ultramarine and white.

My main concern here is to lay in areas in correct relationship, proportion, and angle to each other. Of course, the tilt of the child's head is of the utmost importance, especially since this is a sideview. If the tilt isn't accurate, the child's features will never look right.

The Younger Child's Head: Step 2. In addition to the colors already on my palette, I've added raw umber and a combination of yellow ochre and white. Also, I've mixed a darker skin tone color by adding a bit more Venetian red to a small dab of the original skin tone. Indications of the features and varying shades in the hair are painted in with these colors.

Raw umber is used to lay in the large shadow appearing on the upper quadrant of her face near her eyes and extending up into her forehead. The lighter, less prominent shadows — such as under the eye, a few spots on the cheek, and the neck area — are merely indicated with the darker skin tone. These shadows are placed mainly to create a feeling of form and to provide the basis for later expansion.

Be sure you have the features placed in their proper locations. It will be too late to change them in succeeding steps; so place them clearly enough to enable you to judge their accuracy.

Her dress is expanded only slightly to provide a bit more accuracy in my rendering.

The Younger Child's Head: Step 3. A tiny touch of ultramarine is blended into the raw umber in the large shadow area on her forehead. Then, I combine raw umber and ultramarine and use it in all of the gray, shadowy skin areas. This helps, even at this stage of the painting, to produce the delicate skin tones of a very fair child.

To indicate the lighter area of her lower cheek, I combine yellow ochre, white, and a minute portion of Venetian red. This produces a very pale skin tone. As her cheek rises toward her nose, the color reddens, so I increase slightly the amount of red in the mixture.

The combination of yellow ochre, white, and Venetian red is used in varying strengths to depict her ear. Venetian red and white are laid into her lips.

The pupil and lashes of her eye are raw umber. Ultramarine, white, and raw umber are used for her iris, and then more white is added to this for the white of her eye. Raw umber is stroked on very lightly into the existing skin tone for her eyebrow.

Yellow ochre and white are the predominate colors used in her hair; however, streaks of raw umber are added for its shadows.

Since her arms aren't that difficult to render, I've left them almost flat at this time. The regular skin tone color is brushed on them and her fingers are indicated with the darker skin tone color. Raw umber and blue are laid into their shadow areas.

Her dress is simply roughed in with blue and white with a bit of raw umber here and there to give it form and a little depth. I use a combination of Venetian red, blue, and white with a touch of raw umber to produce the dull purplish background.

All the oil in this painting has been applied thinly to allow for all the overpainting that will take place in step 4.

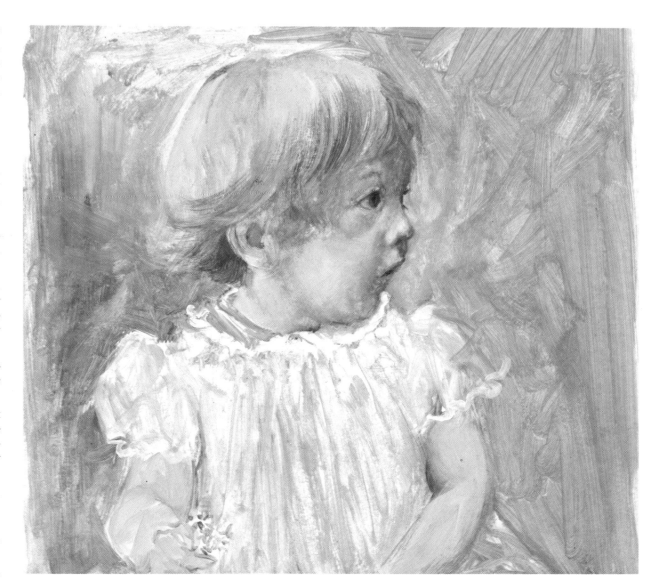

The Younger Child's Head: Step 4. I keep blending and refining the colors I've been working with in the skin tone areas. I use these same colors and work in the same manner along her arms. Besides the high degree of blending here, note my use of redder tones. Around her eyes, her nose, her upper lip, her ear, and her cheek — and occasionally on her forearms — red has been applied ever so faintly and blended in extremely carefully. This red is modified with white in all cases; it must be so thoroughly integrated that it becomes obscure unless you're particularly looking for it.

The highlight colors of her face and arms are as follows: red and white for her nose and yellow ochre, white, ivory black, and blue for her face and arms.

You'll notice I've completely omitted burnt sienna and raw sienna from my skin tones due to the extreme delicacy of this subject's complexion. In extremely fair blonds, these two colors usually aren't desirable and should be reserved for a darker skinned person.

To achieve the blue in her iris, I glaze over its existing color with ultramarine. Venetian red and white combined are used for the highlight on her lips.

I've overpainted her hair with white and cobalt yellow in certain spots. Of course, I've allowed some of the previous painting to show through and worked in raw umber around her ear area where her hair is in shadow.

Her dress is finished off in ultramarine and white with a tiny bit of raw umber used purely for the purpose of toning down the brightness in certain portions of the fabric. The background is predominately raw umber at the bottom which is gently blended into a light mixture of raw umber, ultramarine, and white. This produces a great deal of variation in background tone and provides interest to the dimensional quality of the subject.

SUGGESTED READING

Morning Coffee, oil on Masonite, 48″ x 24″. Private Collection. Black and white are excellent colors for setting off skin tones. The black cat not only adds a mysterious effect but serves to complete the composition of the painting. Note the many textures present: the silver sheen of the tea service, the velvet blackness of the cat, and the lace ruffles of the collar and the cuffs of her dress.

Cooke, Lester, H., *Painting Lessons from the Great Masters,*
Watson-Guptill Publications, New York, 1969.

Doerner, Max, *Materials of the Artist,*
Harcourt Brace Jovanovitch, Inc., New York, 1949.

Hale, Robert Beverly, *Drawing Lessons from the Great Masters,*
Watson-Guptill Publications, New York, 1964.

Henri, Robert, *The Art Spirit,*
Keystone Books (J. B. Lippincott Co.) New York, 1960.

Hogarth, Burne, *Drawing the Human Head,*
Watson-Guptill Publications, New York, 1965.

Grabach, John, *How to Draw the Human Figure,*
Dell Books (Paperback), New York, 1966.

Massey, Robert, *Formulas for Painters,*
Watson-Guptill Publications, New York, 1967.

Mayer, Ralph, *Artist's Handbook of Materials and Techniques,*
Viking Press, New York, 1970.

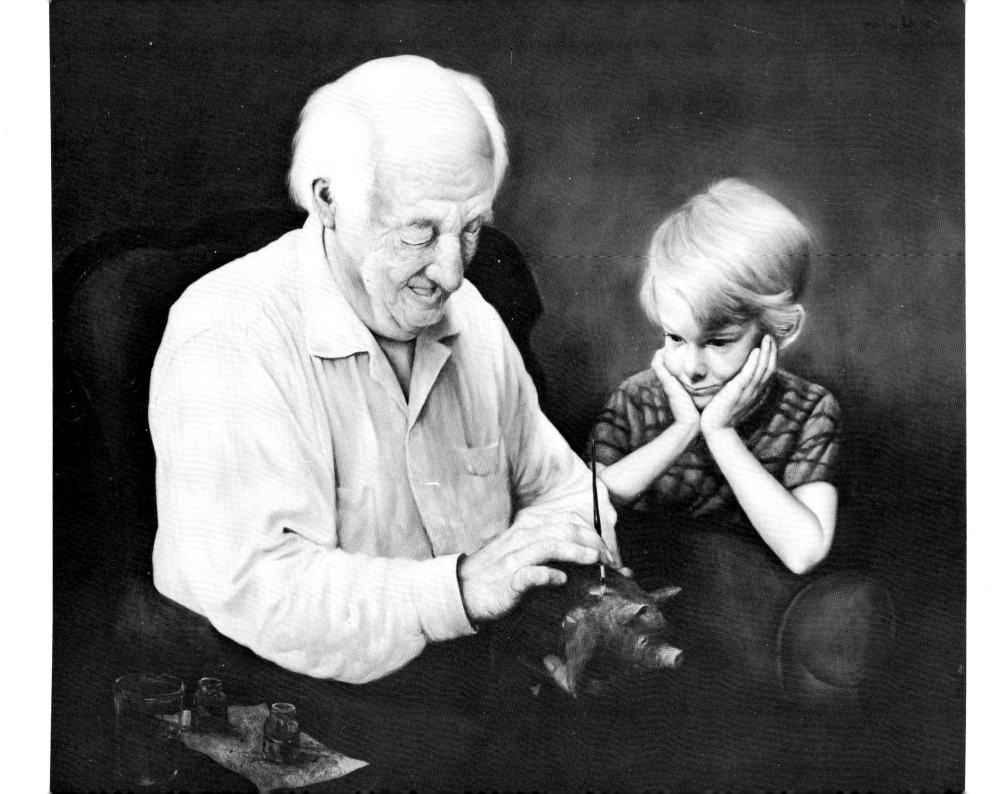

INDEX

Painting the Pig, oil on Masonite, 34'' x 36''. Collection of the artist. Here youth and age sit side by side, and for this moment there's no such thing as a "generation gap." The juxtaposition of the wrinkled, time-worn face of the old man with the smooth, innocent face of the child provides a dramatic contrast.

Girl with Robe, oil on Masonite, 16'' x 20''. Collection Mr. and Mrs. Maxwell Pollack. Here's another semi-nude study of a young woman. Notice how the addition of drapery on the left side has been used to advantage. This drapery completes the triangular composition of the painting; it also serves to complement the flowing, graceful limbs of the model.

Edited by Diane Casella Hines
Designed by James Craig and Robert Fillie
Composed in 10 point Optima by Wellington-Attas Computer Composition, Inc.
Printed and bound in Japan by Toppan Printing Co. Ltd.